SAINTS

AND THEIR

SYMBOLS

The place you are in

needs you today.

—KATHARINE LOGAN

ROSA GIORGI

SAINTS
AND THEIR
SYMBOLS

ABRAMS, NEW YORK

Cover
Ludovico Carracci, *Madonna and Child with Saint Dominic*,
1585–87, Pinacoteca Nazionale, Bologna. Photoservice
Electa/Guerra courtesy of MIBAC.

Opposite
Anton Raphael Mengs, *Saint Peter Enthroned* (detail),
1774–75, Galleria Sabauda, Turin.

Library of Congress Cataloging-in-Publication Data

Giorgi, Rosa.
 [Santi e i loro simboli. English]
 Saints and their symbols / Rosa Giorgi.
 p. cm.
 Includes index.
 ISBN 978-1-4197-0224-2
 1. Christian saints in art–Dictionaries. 2. Christian art and
symbolism–Dictionaries. I. Title.
 ND1430.G55313 2012
 704.9'4863—dc23
 2011027178

Printed and bound in Italy
10 9 8 7 6 5 4 3 2 1

Abrams books are available at special discounts when
purchased in quantity for premiums and promotions
as well as fundraising or educational use. Special editions
can also be created to specification. For details, contact
specialsales@abramsbooks.com or the address below.

THE ART OF BOOKS SINCE 1949

115 West 18th Street
New York, NY 10011
www.abramsbooks.com

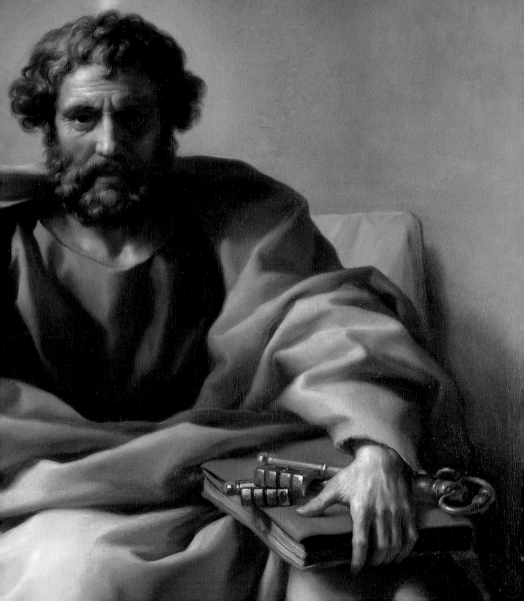

Introduction

While this book is a little more than a calendar, in which saints are listed according to their feast days, it is also a little less than a calendar, since not all the saints for every day of the year are presented. While a little more than a guide for the easy recognition of saints, this book is a little less than a complete hagiography, or life story, of each saint, since the information has been selected and presented with the precise goal of explicating iconographic characteristics. This book does not include all the saints worshiped by the church, but instead presents those figures whose images recur most often in works of art.

Special attention was given to selection of the images, each of which is discussed individually. The fundamental goal was to guide readers' eyes to the object or objects that each saint bears as an iconographic attribute, or rather an identifying element. The identification of each saint begins with the observation of such attributes, which in artistic depictions acquire the value of symbols or emblems. The attributes that serve for the identification of each saint are listed, although not all the attributes are always present in each image—sometimes they are simply not necessary.

Sometimes it is the different combination of several elements that helps distinguish one saint from another. Most people know, for example, that Saint Lawrence is often depicted being tortured on a gridiron, but his attributes also include being dressed as a deacon, having the appearance of a young man, and holding a palm leaf in his hand. Perhaps

not everyone knows that Saint Vincent of Saragossa—who, like Lawrence, was also a deacon—also has a gridiron as an attribute (although a small one, like a brazier) along with his deacon's vestments, youthful appearance, and palm branch. How does one tell them apart? To help the reader through such situations, each entry includes a short sidebar that lists all the iconographic attributes of the saint (for Vincent, aside from the palm branch and the gridiron, there is a millstone, a raven, a boat, a bunch of grapes, etc.).

Each entry also includes short biographical notes, information on patronage, and the necessary background to recognize the saint, including cases of possible confusion.

The East-West Schism, the division of the Church of Rome into Eastern (Greek) and Western (Latin) branches—today known as the Eastern Orthodox Church and the Roman Catholic Church—has led to differences in the presentation of saints. This book gives special attention to Western art, since the Eastern Church early on established an iconographic canon (only subject to stylistic changes), whereas in the West, the recognition of the importance of sacred images resulted in artistic development that reflects how devotion has changed from period to period.

Our hope is that this book will make it easier for the reader to interpret images of saints, which are such an important subject in the artistic expression of Western civilization.

Basil the Great

Feast day: January 2 in West, January 1 in East

Appearance: elderly man with a long beard, dressed in bishop's vestments and pallium

Attributes: book, scroll, dove

Can be confused with: other Fathers of the Eastern Church

The image of Saint Basil the Great, one of the Fathers of the Greek Church, was probably created in an Eastern setting but also appears in the West without any particular additions or differences. Eastern iconography often presents him together with Saints John Chrysostom, Gregory of Nyssa, and Gregory of Nazianus—the four Byzantine hierarchs—and gives him the appearance of an elderly man with a long beard, wearing bishop's vestments and a pallium, the narrow band of wool worn across the shoulders. Western art usually presents him in the same way, sometimes with the addition of a book or scroll or the dove that is symbolic of divine inspiration.

Biographical notes
He lived in Cappadocia (in modern Turkey) from 328 to 379, fought against the Arian heresy, and created the monastic rule for the Eastern Church.

Patronage
Protector of Basilian monks

Francisco de Herrera the Elder,
Saint Basil Dictating His Rule,
17th century, Louvre, Paris.

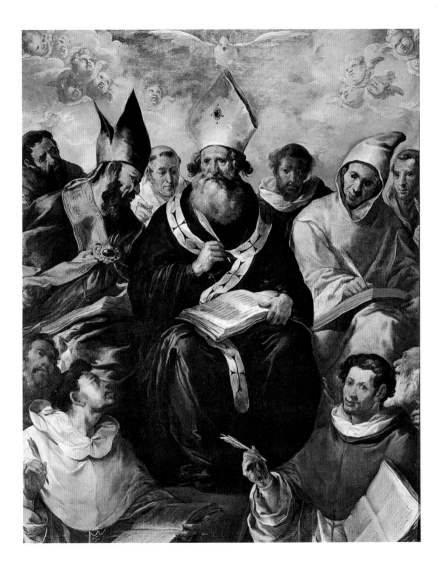

Paul the Hermit

Feast day: January 10

Appearance: half-dressed or covered by clothing made of woven palm fronds; long, untidy beard

Attributes: raven with bread in its beak, lions, skull

Can be confused with: Saint Onuphrius, Saint Jerome

The legend that grew up around the cult of Saint Paul the Hermit, which began in Egypt in the fourth century and took hold throughout Europe beginning in the thirteenth, was created by Saint Jerome, who around 375 wrote a biography of Paul based on episodes from the Bible. The legend of Saint Paul's life has many elements in common with the life of Saint Anthony the Abbot and with some of the events of Saint Onuphrius. The garment of woven palm fronds and the long, untidy beard became emblematic of a life of isolation in wild and harsh locales, and joined to these were the attributes of the penitent, such as the skull. The raven with the bread in its beak is a recurring motif, drawn from stories of the prophet Elijah. The lions that are sometimes present in the depictions of the saint refer to an episode told about Saint Anthony who, after visiting Paul the Hermit in the desert, saw Paul's soul fly into the sky and rushed to bury his body, but having no tools, was helped by two lions.

Biographical notes
Traditionally considered the first hermit, Paul lived in Egypt between the third and fourth centuries. Originally from Thebes, he fled to the desert to escape the persecutions under Emperor Decius. He was drawn to the solitude of the desert and spent the rest of his life there.

Patronage
Protector of makers of mats

Mattia Preti, *Saint Paul the Hermit*, 1692, Museo di Castelvecchio, Verona.

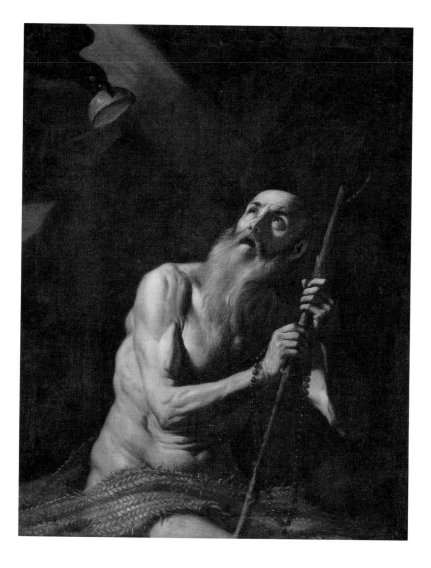

Maurus

Feast day: January 15

Appearance: wears the black habit of the Benedictines

Attributes: abbot's staff, spade, crutch, scales

Biographical notes

Maurus was born in Rome around 500. The first disciple of Saint Benedict, he trained in the monastery of Subiaco and later moved to France, bringing the Benedictine rule to that region. He died in 584.

Patronage

Invoked against rheumatism and formerly gout, when it was a more common affliction; protector of gardeners, coal merchants, boiler makers, and the lame

The most widespread image of Saint Maurus portrays him together with Saint Benedict, of whom he was an obedient disciple, or with Saint Placid, alongside whom he learned the monastic life at the monastery of Subiaco. Among his iconographical attributes is the abbot's staff, which refers to the position of abbot that he assumed most likely when Saint Benedict left Subiaco to go to Monte Cassino; the spade is ascribed to Saint Maurus because of its association with digging, a result of the translation of his relics (the transfer of holy objects, often bodily remains, to a new location) in the ninth century to the monastery soon called Saint-Maur-des-Fossés ("Saint Maurus of the Moats") and of the cult that developed around them. Because of the devotion of the lame and those suffering from gout, who brought their crutches to the saint, the crutch has also become one of his possible attributes. Saint Maurus brought the Benedictine rule to France, which explains the occasional appearance of scales as an attribute, for the Benedictines used scales to weigh the food of the monks.

Alessandro Magnasco, *Saint Maurus Heals a Child*, 1727, church of the Conversione di San Paolo, San Paolo d'Argon (Bergamo).

Anthony

Feast day: January 17

Identifying situation: a figure surrounded by various demons

Appearance: dressed as a hermit monk, sometimes with the Greek letter "Tau" decorating his clothing

Attributes: Tau-shaped staff with bell, pig, demon, book, fire

Can be confused with: Saint Bernard of Clairvaux and Saint Anthony of Padua, who in the oldest images has fire among his attributes

Biographical notes

Anthony lived in Egypt between 251 and 356. He took part in important doctrinal questions of the church, supported persecuted Christians, and spoke out against Arianism, a movement which denied that Christ was God, instead suggesting he was a separate and inferior being.

Patronage

Invoked against shingles, or "St. Anthony's fire"; protector of pork butchers, basket-makers, and domestic animals

Anthony lived as a hermit in absolute solitude, where he experienced continuous temptations for twenty years. During this time, he attracted many disciples. Around 306 he reentered society and gave in to the supplications of his disciples, becoming their spiritual guide. In the most common image of Saint Anthony (also called Anthony the Abbot, Anthony of Egypt, and Anthony of the Desert), he is depicted in the clothes of an Antonine monk, wearing a cloak of dark brown fabric with a hood pulled up over his head at times. Numerous objects accompany the saint as iconographic attributes useful in clearly identifying him. One example is the Tau-shaped staff (sometimes the Tau appears on its own without the staff, decorating his cloak) with a bell, a typical object of hermits who used it to drive off attacks by demons. The pig became an attribute of Anthony in the West because the friars of Saint Anthony raised swine to use their fat to cure shingles, and thus these animals were allowed to freely wander their monasteries.

Hieronymus Bosch, *The Temptations of Saint Anthony* (detail), 1510, Prado, Madrid.

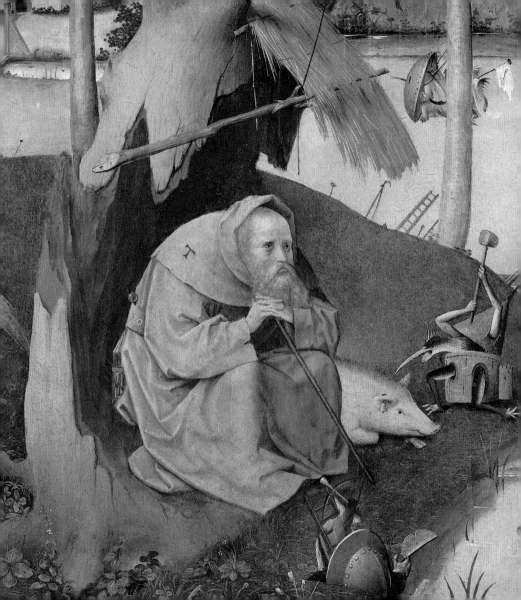

Anthony

Typical elements in depictions of Saint Anthony are a chained devil, a devil that the saint is holding underfoot, or several fierce devils that are attacking him. His hagiography relates numerous episodes of temptation that he experienced as violent attacks by demons. These episodes from the saint's life offered artists opportunities to express their fantasies in works that always emphasize Anthony's pacific nature in contrast to the ferocity of the frightening demons. In terms of this iconography, Anthony should not be confused with Saint Bernard of Clairvaux, who is also often depicted with defeated or chained demons. Exact recognition can be made on the basis of clothing, for Bernard appears in the white habit of the Cistercian monks.

Anonymous Aragonese painter,
Temptations of Saint Anthony,
late 15th century, Museo de
Bellas Artes, Bilbao.

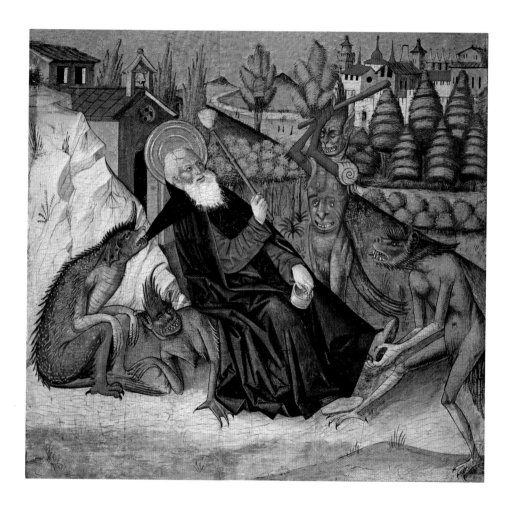

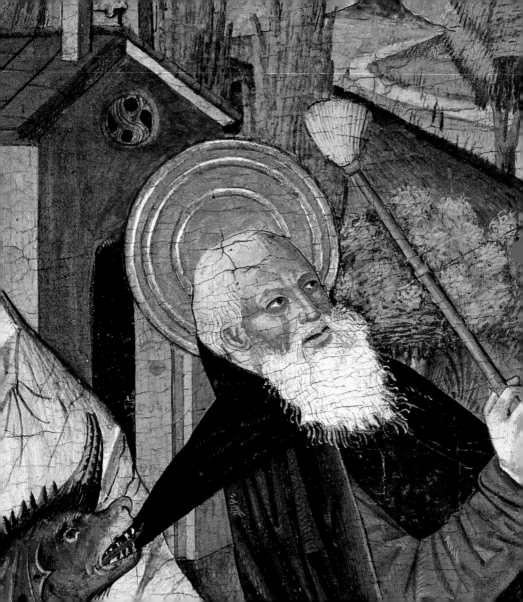

Sebastian

Feast day: January 20

Appearance: usually presented only partially clothed with his body pierced by arrows; in rare instances appears as a soldier

Attributes: arrows, palm branch

Arrows are the symbol that makes Saint Sebastian instantly recognizable, for he was shot with arrows when he refused to sacrifice to the pagan gods. Arrows thus signify sacrifice, but at the same time they mean miraculous salvation. After being pierced with numerous arrows, Saint Sebastian was left to die, but the Christian widow Irene came to his assistance, saving him. He went back to the emperor and again professed his faith in Christ, thereby earning martyrdom, which is why he is often depicted with a palm branch. Diocletian had him clubbed to death, after which his body was thrown into Rome's Cloaca Maxima sewer—events that have had little influence on the saint's iconography, which has always shown a preference for the depiction of torture by arrows.

Biographical notes
A soldier originally from Gaul, Sebastian lived between the third and fourth centuries in France and Italy and enrolled in the Roman army during the reign of Diocletian. He became a tribune of the Praetorian Guard, converted to Christianity, and was tortured by being shot with arrows before being clubbed to death.

Patronage
Invoked against the plague; protector of archers, upholsterers, athletes, and policemen

Guido Reni, *Saint Sebastian*, 1615–16, Galleria di Palazzo Rosso, Genoa.

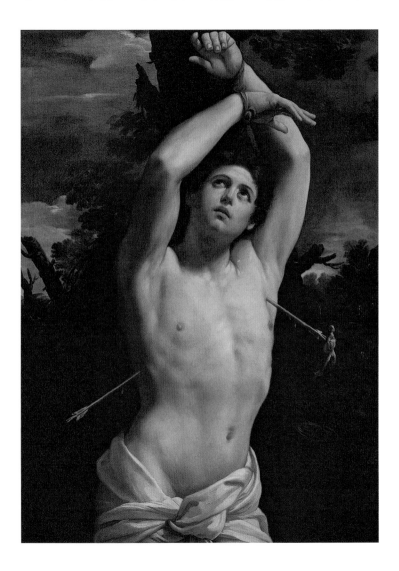

Agnes

Feast day: January 21

Appearance: a girl, in rare cases with long hair and a white outfit

Attributes: a lamb, palm branch, burning coals, flames at her feet

Agnes was the first saint to be given an iconographic attribute. The lamb, her attribute, makes its first appearance in the great mosaic of the Holy Virgins in Saint Apollinare Nuovo in Ravenna (sixth century). The choice of the lamb was based on its assonance with her name (in Latin, only a single vowel changes between *agnus* and *Agnes*). The first depictions of the saint appear, however, in small glass tondos decorated in gold found in the catacombs that are dated to the end of the fourth century. In these Agnes is presented in the act of prayer, her arms raised skyward against a simple setting of trees, an allusion to her arrival in Paradise.

Biographical notes
Agnes lived during the end of the third and the beginning of the fourth centuries in Rome, where she died a martyr, probably during the persecutions under Diocletian around 305.

Patronage
Protector of virgins, engaged couples, and gardeners

School of Zubarán, *Saint Agnes*, c. 1640, Museo de Bellas Artes, Seville.

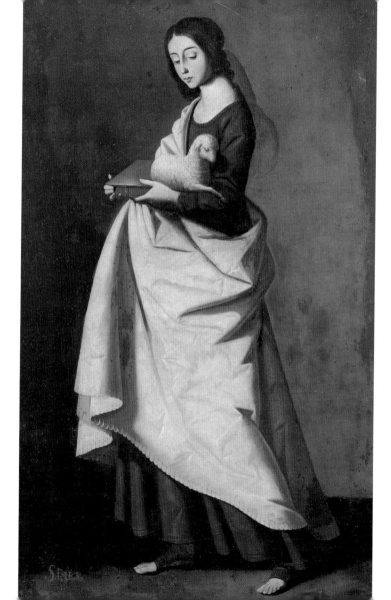

Agnes

Agnes's story is based on two different traditions. According to the Latin tradition, which was followed by Saint Ambrose, Agnes was a twelve-year-old girl who was executed by being stabbed in the throat during the persecutions under Emperor Diocletian. According to the Greek tradition, presented by Saint Damasus, she was an adult virgin who, having refused to sacrifice to the goddess Vesta, was led nude to a brothel. God made her hair grow long enough to cover her entire body and sent an angel to dress her in white. She was tortured in various ways and then killed when her throat was cut. The tortures were said to have included being thrown into a fire, but she remained unscathed for the flames divided around her. The memory of this miraculous event shows up in various early depictions of the saint (sixth century), in which flames are depicted around her feet, and it appears in later images in which burning coals are shown.

Saint Agnes Between Two Popes (detail), 7th century, Basilica of Saint Agnes Outside the Wall, apsidal vault, Rome.

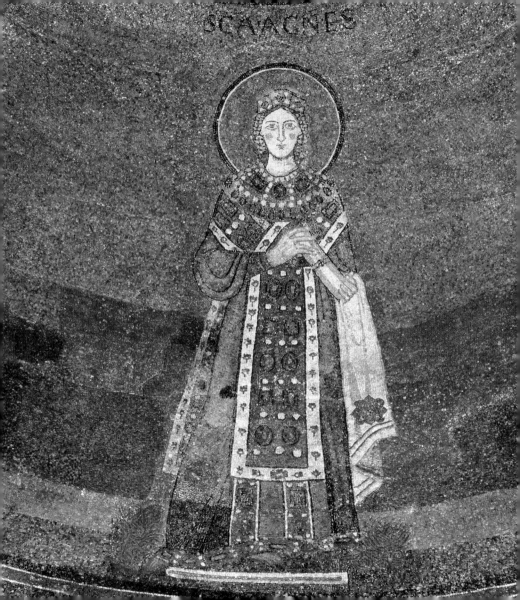
SCA AGNES

Vincent of Saragossa

Feast day: January 22

Appearance: wears a deacon's dalmatic, tunicle, or stole worn crosswise

Attributes: gridiron, millstone, raven, boat, bunch of grapes, hook, palm branch

Can be confused with:
Saint Lawrence

The appearance and attributes of the martyr Vincent were drawn directly from his Acts, made known by Saint Augustine and Prudentius. Saint Vincent wears the vestments of a deacon, including a dalmatic, tunicle, or stole worn crosswise, and he bears the palm branch that is symbolic of his martyrdom. In addition to these elements is a series of possible attributes that refers to the tortures he suffered and to his martyrdom, especially a gridiron, most often in the form of a brazier, which recalls the torture to which he was subjected after already having been tied to a cross of Saint Andrew and flayed with iron hooks. Exhausted by these tortures, he died in prison, at which point his body was first exposed to animals and then, since it had been defended by a large raven, thrown into the sea tied to a millstone. Miraculously the body did not sink, and Christians were able to recover it and give it a suitable burial. The least frequently depicted of his attributes, a bunch of grapes, is related to his protection of winemakers and viticulturists.

Biographical notes
Vincent lived in Spain between the third and fourth centuries. He became deacon and the most trustworthy collaborator of Valerius, bishop of Saragossa. He was martyred in Valencia in 304, during the persecutions under Emperor Diocletian.

Patronage
Protector of vintners, viticulturists, tile-makers, seafarers

Ludovico Carracci, *Saint Vincent Martyr*, 1580–82, Romagnolo Collection, Bologna.

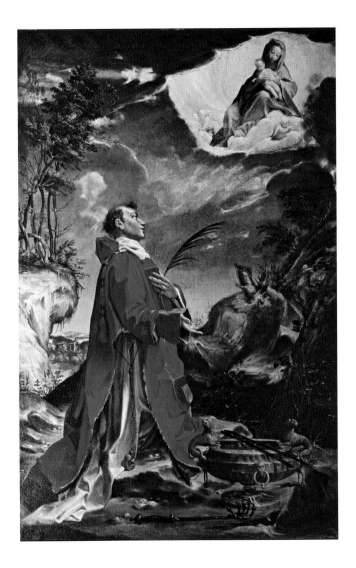

Ildephonsus of Toledo

Feast day: January 23

Appearance: wears the black habit of the Benedictines, rarely a bishop's vestments, with a tonsure

Attributes: the chasuble given to him by the Virgin Mary, a crosier

Can be confused with: Saint Bernard of Clairvaux

The principal attribute of Saint Ildephonsus is a chasuble (the sleeveless outer garment worn by the officiating priest during the rite of Mass), which, according to his hagiography, he was given directly by the Virgin Mary—but only rarely is this the sole attribute of the Spanish bishop to appear in works of art, for it is almost always combined with the black habit and tonsure (shaven crown) of a Benedictine monk. In this way his image makes reference to the monastic life he led before being made bishop of the dioceses of Toledo; in some rare cases Ildephonsus is depicted as a bishop with a miter and pastoral staff, or he is shown in a study, in reference to his writings.

Biographical notes
Benedictine abbot, then bishop of Toledo, Ildephonsus lived in Spain from 607 to 667. He wrote theological works, including a treatise on the virginity of Mary.

Patronage
Protector of the city of Toledo

El Greco, *Saint Ildephonsus of Toledo*, c. 1603, Iglesia del Hospital de la Caridad, Illescas.

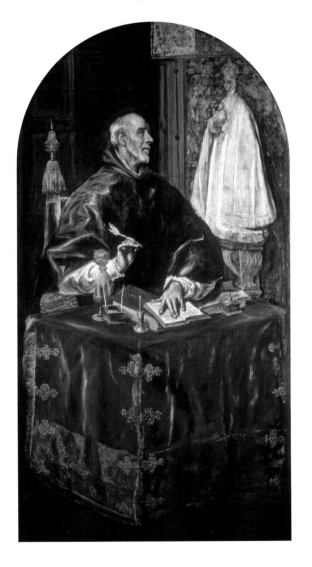

Ildephonsus of Toledo

The Virgin Mary's appearance to the saint acknowledges Ildephonsus's great devotion to her. He wrote an important treatise in defense of her virginity (*De illibata Virginitate Sanctae Mariae*). According to revelations made in the biography of Ildephonsus written by his immediate successor, Julianus of Toledo, Saint Ildephonsus received in person the apparition of the Virgin during the feast of the Assumption, for which he had prepared with three days of fasting. Mary, descending from the sky and sitting on the bishop's throne, thanked him for his efforts and gave him a chasuble with which to dress himself, telling him, "Thou art my chaplain and faithful notary." Other apparitions appear in this saint's iconography: Mary appeared to Ildephonsus while he was writing in his study, and he was visited by Saint Leocadia, who also thanked him in the name of Mary and from whose mantle the bishop cut a strip of cloth.

Francisco de Zurbarán, *Saint Ildephonsus of Toledo Receives the Chasuble from the Madonna*, 1631–40, Royal Monastery of Santa Maria de Guadalupe, Guadalupe.

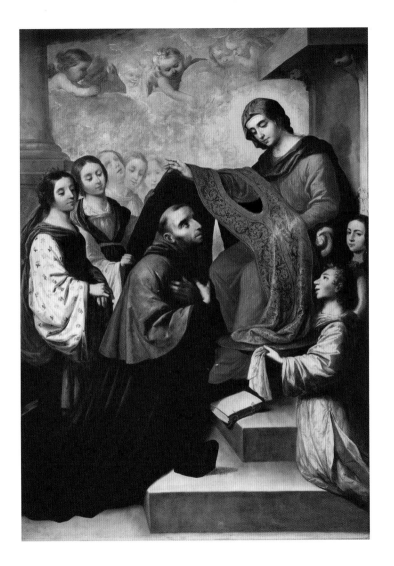

Thomas Aquinas

Feast day: January 28

Appearance: a man of robust constitution, wearing the white habit and black mantle of the Dominicans

Attributes: sun on chest, dove, book, pen, model of church

Can be confused with: Saint Dominic, who wears the same clothes but has different attributes

Biographical notes
Born at Roccasecca (in Latium, Italy), Thomas Aquinas was educated at the abbey of Monte Cassino, where he became a Dominican friar. He studied in Paris and later at Cologne, and he wrote the *Summa theologiae*, a systematic attempt to give a scientific, philosophical, and theological foundation to Christian doctrine. He died in 1274.

Patronage
Protector of students, theologians, academics, booksellers, and pencil-makers

The appearance of Saint Thomas Aquinas, usually shown with a robust body, corresponds to accounts from his contemporaries (including the malicious nickname "dumb ox," given to him by his fellow students). Aside from his girth, the primary attribute that makes him recognizable and distinguishes him from other saints of the Dominican order is a radiant sun on his chest, in reference to the vision had by a Dominican friar in Brescia, who saw Saint Thomas with a light on his chest that illuminated the church. The book the saint holds, sometimes accompanied by a pen, is emblematic of the sacred studies and important works he wrote. In some cases he holds a model of a church in reference to his title Doctor of the Church.

Fra Angelico, *Saint Thomas Aquinas*, 1438–46, Museo di San Marco, Florence.

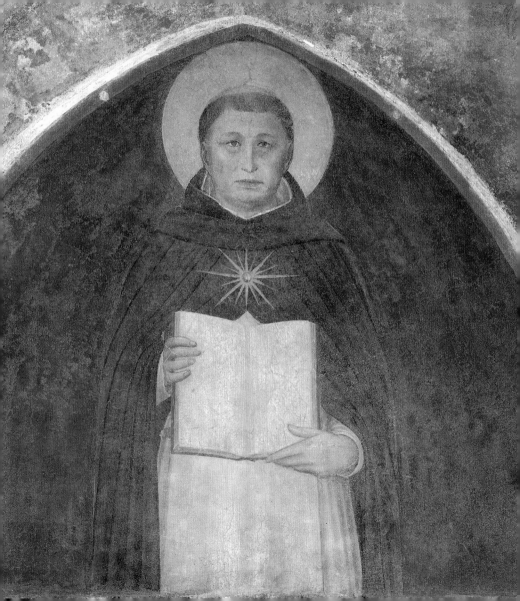

Thomas Aquinas

Various allegorical depictions of Saint Thomas Aquinas show him seated on his throne, within a circle of light that may be a reference to the symbolic circle of knowledge. The saint holds up texts that allude to inspired knowledge, while at his sides are Plato and Aristotle, in memory of the ancient doctrines that were the subject of his studies. In such depictions, the saint often treads upon an image of Averroës as a visible sign of his refutation of Averroist doctrine, a philosophy based on Aristotle that commented on human intellect and the soul. In the image on the opposite page, depicted above the saint are the four evangelists (Matthew, Mark, Luke, and John), Saint Paul, and Moses with the tablets of the law, and at the very top Christ Pantocrator is visible.

Benozzo Gozzoli, *The Triumph of Saint Thomas Aquinas*, 1471, Louvre, Paris.

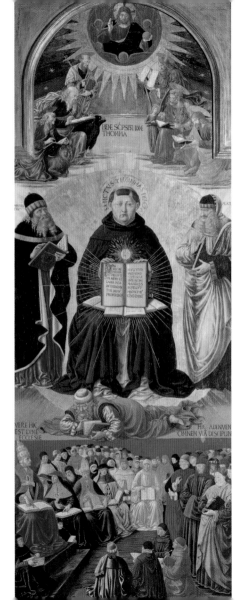

LENE SÓ PSITS LÓME
THOMMA

SANCTVS TROMHA SEIO

VERE HIC
EST LVME
ECCLESIE

HIC ADINVEN
OHNEM VIÃ DISCIPLIN

Julian the Hospitaller

Feast day: January 29

Appearance: dressed as a horseman or knight

Attributes: falcon, deer, sword

The legendary figure of Saint Julian has so little historical support that he is no longer included in the *Roman Martyrology*. His incredible story has its own appeal: A nobleman and lover of hunting, he killed, as a result of a tragic error, the two people he found sleeping in his bed while overcome by blind jealousy. He believed them to be his wife and an unknown lover, but they were instead his own parents who had come to visit him and had been welcomed in his absence by his wife. Some cycles dedicated to Julian present various other events of his life, but most often one encounters images of the saint dressed as a nobleman (on horseback, with a falcon, near a deer) or armed with a long sword (symbolic of the parricide), or he is shown as the kindly and tireless hotelier, the activity that he performed without rest for the remainder of his life as an expiation for his sin.

Biographical notes

According to tradition, he was a fourth-century nobleman who, by terrible error, killed his parents. To expiate that sin he dedicated the rest of his life to sheltering and caring for poor pilgrims.

Patronage

Protector of hoteliers and travelers

Saint Julian Killing His Parents, 15th century, Museo Poldi Pezzoli, Milan.

Brigid of Ireland

Feast day: February 1

Appearance: wears the white habit of a nun with a veil and sometimes also a black mantle

Attributes: crosier, cow, fire, model of church, "Saint Brigid's cross," burning fire or lantern

Saint Brigid of Ireland chose a religious life and founded one of the first monasteries in Ireland following the evangelization begun by Saint Patrick. In addition to these basic details, there are various legendary tales drawn from later biographies, and the episodes drawn from these sources have influenced the images of the saint, depicted in a white nun's habit with the staff of an abbess. She may hold a model of a church in reference to the foundation of the monastery of Kildare. Sometimes her attributes include a cow, since at the beginning of her monastic life she took care of the animals. She may also be shown with a small fire or a lantern. In the most popular and recent depictions, she bears a "Saint Brigid's cross" made of woven straw.

Biographical notes
Brigid lived in Ireland between the fifth and sixth centuries and was abbess of the monastery at Kildare. She died around 525.

Patronage
Protects milkmen, poets, blacksmiths, healers, cows, and farmyard animals

Lorenzo Lotto, *Brigid of Ireland Transforms Water into Beer and Heals a Blind Man*, detail from the *Lives of Saints Brigid and Barbara*, 1524, Villa Suardi oratory, Trescore Balneario (Bergamo).

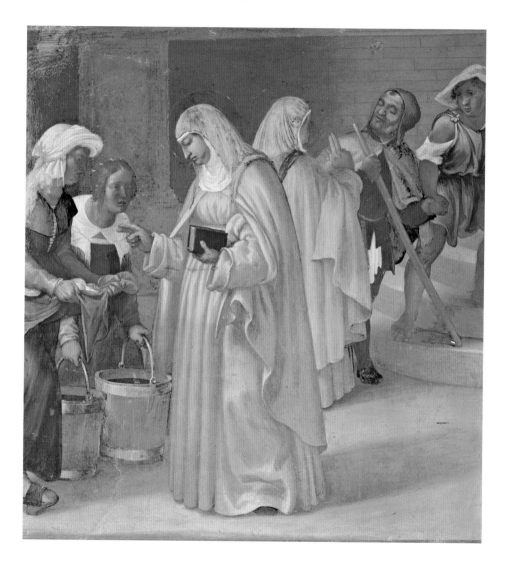

Blaise

Feast day: February 3

Identifying situation: being tortured with carding combs

Appearance: bishop's vestments

Attributes: carding comb, candles, sometimes a child or a pig

A carding comb for wool is the primary attribute ascribed to Bishop Blaise. This is part of the tradition that was handed down and eventually collected in *The Golden Legend*, according to which Blaise, before being martyred by decapitation under Roman Emperor Licinius, was atrociously tortured with carding combs (together with his nomination as bishop of Sebaste in Armenia, this is the only certain fact known about him). Thus the recurrent image of Blaise is that of a bishop who, along with the insignia of his office, holds a carding comb.

Biographical notes
Blaise lived between the third and fourth centuries, was bishop of Sebaste in Armenia, and died a martyr, beheaded in 316 during the persecutions under Emperor Licinius.

Patronage
Invoked against diseases of the throat and hurricanes; protector of shepherds, farmers, carders, players of wind instruments, mattress-makers, and throat doctors

Andrea Delitio, *Saint Blaise* (detail), 1477–81, fresco in the choir, cathedral of Santa Maria Assunta, Atri (Teramo).

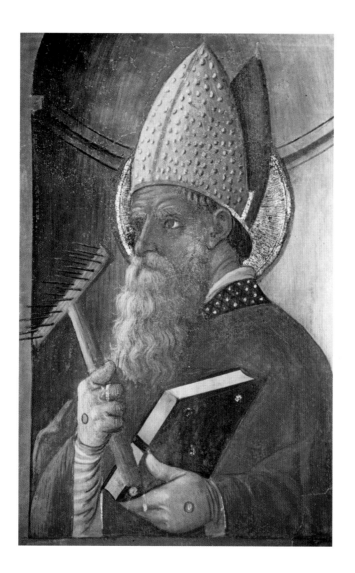

Blaise

The legend of the saint was recorded in the text by Jacobus de Voragine—*The Golden Legend*—adding other attributes to the figure of Blaise. These include a child the saint saved from suffocation by removing a fishbone from his throat; the candles that a woman brought to Blaise while he was imprisoned during the persecutions; a pig that he returned to an old woman after saving it from a wolf that was about to kill it (he explained to the wolf that it belonged to an old woman, and the wolf released it). All these elements often appear in the iconography of Blaise.

Luigi Bartolini, *Miracle of Saint Blaise*, 17th century, chapel of Santa Maria della Scaletta Hospital, Imola (Bologna).

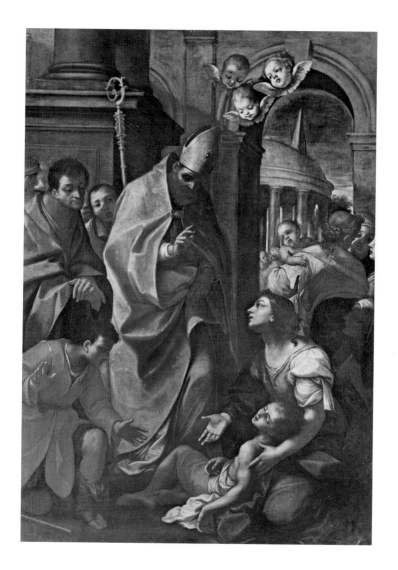

Veronica

Feast day: February 3

Appearance: young, sorrowful woman

Attribute: the "veronica," a cloth impressed with the holy image of Jesus

Veronica is a creation of popular devotion, giving identity to the woman who, on the route to Calvary, offered a moment's rest to Jesus, drying his face with a cloth and receiving in recompense the impressed image of the Savior: the *vera icon* (Gr. *eikon*), meaning "true image" (an expression that unites a Latin word to a Greek one), from which, by assonance, the name *Veronica* is derived. Her iconography, which has seen widespread diffusion since the Counter-Reformation, is inseparable from the cloth on which the face of the suffering Jesus appears.

Biographical notes
Veronica is the legendary figure based on the woman who, on the route of Calvary, dried Jesus's face with a cloth on which his image remained impressed.

Patronage
Protector of embroiderers, cloth workers, launderers, cloakroom attendants, photographers

Jacques Blanchard, *Saint Veronica*, 1633–64, Hermitage, St. Petersburg.

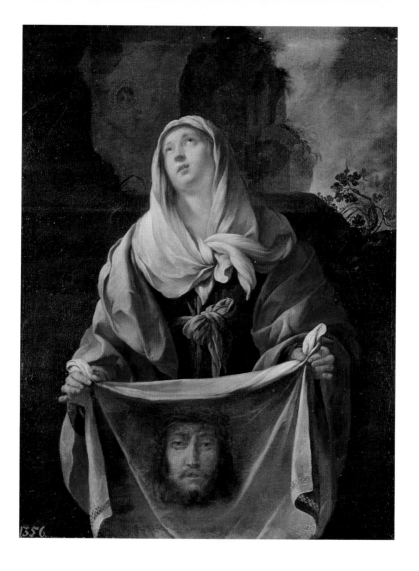

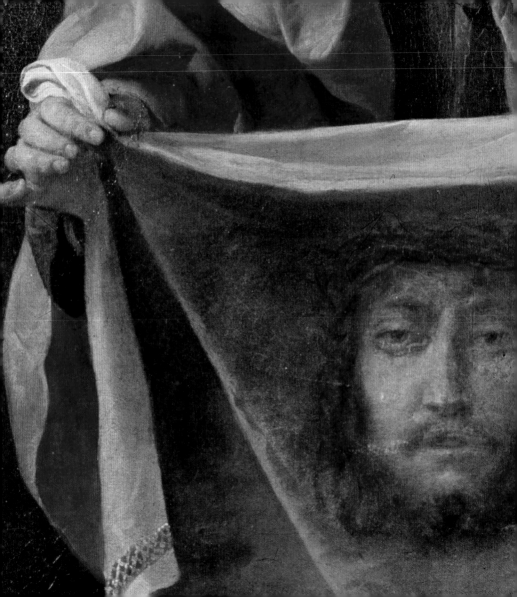

Agatha

Feast day: February 5

Identifying situation: breasts being torn off with pincers

Appearance: young woman

Attributes: palm branch, cut-off breasts on a plate, torch or lit candle

Agatha, a young woman of noble family who had converted to Christianity, was subjected to tortures after refusing to sacrifice to the idols and rejecting Quintianus's (the provost of Sicily's) amorous advances. Tradition (a somewhat late tradition, since it dates to the sixth century) attributes several methods of torture to Agatha, but the one that determines her identity in art is the removal of her breasts with pincers. The saint was also tied by the feet and hung upside down, but images of that torture have most often been used in her iconography in complete cycles. She was healed of the wounds done to her breasts by the miraculous visit of Saint Peter who appeared to her in prison. But the Roman prefect Quintianus had another hard test for her: walking on live coals and shards of glass. At that moment Mount Etna began to erupt and an earthquake shook the ground, so the people of Catania implored the prefect to spare her, but she died of her sufferings in prison.

Biographical notes
Born in Catania, Sicily, in the third century, Agatha was martyred under Emperor Decius.

Patronage
Invoked against breast ailments, fires, and volcanic eruptions; protector of wet nurses, bell founders (because molten bronze resembles lava and the shape of bells resembles breasts), nurses, and Sicilian weavers

Francesco Fontebasso, *Saint Peter Visiting Agatha in Prison*, 1761–68, parish church, Trescore Cremasco (Cremona).

Dorothy

Feast day: February 6

Appearance: young woman with a floral crown

Attribute: fruit and cut flowers gathered in the folds of her dress or in a basket

According to the Acts of her martyrdom, Dorothy, daughter of a senator, was killed at Caesarea in Cappadocia during the persecutions under Diocletian. Not one of the tortures inflicted on her has influenced her image in art, not even her death by decapitation—the symbolic palm branch being the only element related to her martyrdom. She most often appears alone bearing flowers and fruit in reference to the tradition that tells of her being mocked as she was led to her death by a young man named Theophilus, who asked to be sent flowers and fruit from the land without winter, the paradise where she claimed to be going. According to this story, one year after her death Dorothy sent flowers and fresh fruit by way of an angel to Theophilus, who then converted and was himself martyred.

Biographical notes

Dorothy was a virgin martyr at the beginning of the fourth century, during the persecutions under Emperor Diocletian.

Patronage

Protector of gardeners, florists, brewers, and newlyweds

Francisico de Zurbarán, *Saint Dorothy*, c. 1640, Museo de Bellas Artes, Seville.

S.DOROTEA

Apollonia

Feast day: February 9

Identifying situation: teeth being extracted with large pincers

Appearance: most often a young woman

Attributes: palm branch, pincers with tooth, pyre, scalpel

A big pair of pincers and a tooth or several teeth have become the primary symbols for recognizing the deaconess Apollonia of Alexandria. According to the sources and the ancient tradition handed down by Saint Dionysius, who was bishop of Alexandria at the time, Apollonia was an elderly woman but was later confused with another Apollonia, and her appearance gradually became that of a young woman. During the persecution, having refused to deny her faith and sacrifice to the idols, she was tortured and struck in the face, breaking her jaws and knocking out her teeth. This was the basis for the iconographic simplification of the pincers, as though her teeth had been torn out. She died by throwing herself into a fire to escape her tormentors, who were trying to force her to recite blasphemous phrases. For this reason her attributes include a pyre, although it rarely appears.

Biographical notes
Apollonia lived in the third century and was martyred in 249 under Emperor Philip the Arabian.

Patronage
Protector of dentists

Ercole de' Roberti, *Saint Apollonia*, from the Griffoni Polyptych, 1472–73, Louvre, Paris.

Scholastica

Feast day: February 10

Appearance: wears the black habit of a Benedictine nun

Attributes: dove, book of the rule, pastoral staff

Saint Scholastica is depicted as a Benedictine nun in a black habit. In reference to her belonging to the female branch of the order and her role as abbess, she may be depicted with the book of the rule and an abbot's staff. The attribute that is more specifically related to her is a dove, based on a story told in the *Dialogues* written by Saint Gregory the Great. Scholastica had asked for a meeting with her brother, Saint Benedict, to discuss "the joys of heaven." When evening came and Benedict expressed the desire to go home, Scholastica, who wanted him to stay longer to continue their spiritual discussion, prayed to the Lord to make it rain and received in response such a violent downpour that her brother was forced to stay the night. A few days later Saint Benedict saw a dove fly up into the sky and knew it to be his sister Scholastica, understanding immediately that his sister had died.

Biographical notes

Born in Norcia, Italy, she lived between circa 480 and circa 547. She was the sister, perhaps twin, of Saint Benedict and was a Benedictine nun, first at the female monastery of Busiaco and then at that of Plombarola.

Patronage

Invoked against storms, lightning, and rain; protector of the Benedictine order and children suffering convulsions

Januarius Zick, *Saint Scholastica*, 1760, Benediktinerstift, Kremsmünster.

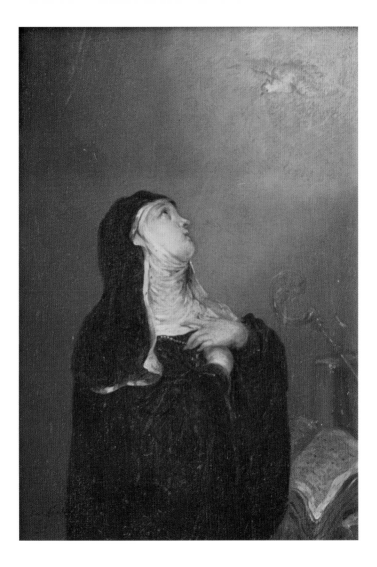

Valentine

Feast day: February 14

Appearance: wears bishop's vestments or is dressed as a priest

Attributes: crosier, palm branch, epileptic child, blind girl

Images of Saint Valentine are somewhat rare because of the uneven spread of his cult, which in Rome, where he died, had already diminished around the eighth century, while it stayed alive at Terni (his birthplace and where he was probably bishop), the city to which his relics had been moved. *The Golden Legend* dedicates only limited space to Saint Valentine, relating the story of a discussion between the emperor Claudius and a prefect who, almost convinced to believe in Christ, asks the bishop Valentine to heal his daughter's blindness. This healing, and especially the subsequent conversion of the prefect's entire family, became the cause for the bishop's death by decapitation.

Biographical notes
A martyr of the third century, Valentine died on the Flaminian Way near Monte Milvio.

Patronage
Invoked against stomach pains; protector of epileptics, lovers, and the betrothed

Girolamo Brusaferro, *Madonna with Saints Valentine and Nicholas* (detail), 1732, parish church, Mareson di Zoldo (Belluno).

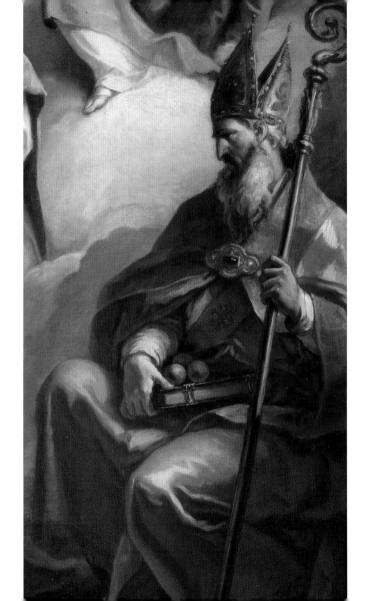

Margaret of Cortona

Feast day: February 22

Appearance: wears the habit of a Franciscan tertiary

Attributes: small dog, crucifix, skull

From the earliest image of Saint Margaret of Cortona, the primary element for identifying her has been the habit: It is that of a Franciscan nun, made using the least expensive fabric then in existence, held at the waist with a cord in keeping with the custom of the order, with a dark mantle and a veil covering her head. With the expansion of her worship, especially at the end of the sixteenth century, Saint Margaret was given the figure of a penitent, and the crucifix and skull were added to her specific attributes. The small dog that often helps distinguish her from other figures of penitents is among her attributes because it was her dog that led her to the tragic discovery of the murdered nobleman Arsenio, with whom Margaret had lived nine years.

Biographical notes

Born around 1247, she was seven when her mother died. To escape mistreatment from her stepmother, she left home and went to live in the castle of the nobleman Arsenio of Montepulciano. Arsenio was mysteriously killed, her father refused to take her back, and she found shelter in the home of two pious women. She then began her life of penitence as a Franciscan tertiary. She died in 1297.

Patronage

Protector of penitents

Giovanni Lanfranco, *Ecstasy of Saint Margaret of Cortona*, 1622, Galleria Palatina, Palazzo Pitti, Florence.

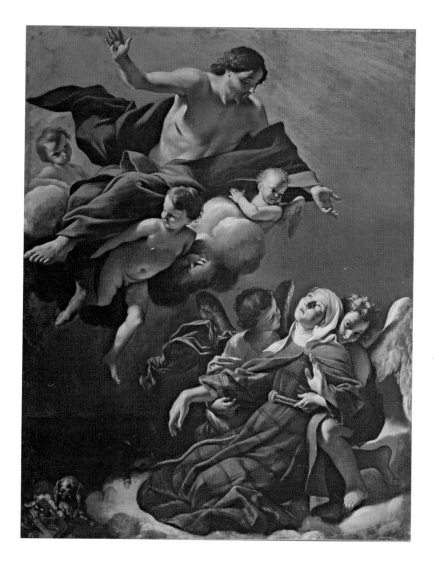

Frances of Rome

Feast day: March 9

Appearance: wears the black habit and white veil of Benedictine nuns

Attributes: guardian angel, bread

The image of Saint Frances of Rome is that of a charitable woman who has dedicated her life to a special purpose (the habit of the Benedictines reflects the desire of the Oblates of Mary, the community she founded, to follow the rule of Saint Benedict). She maintained this dedication over the course of her life even during the hardest moments (her agreement to get married, the political violence directed against her family, the wounding and illness of her husband, and so on), supported by apparitions and revelations. The guardian angel, her primary attribute along with the bread she distributed to the poor, appeared to her in a continuous vision that, according to her hagiography, lasted several years. The depictions of the Virgin putting the Child into her arms also correspond to a vision the saint had. Sometimes the saint's supernatural voyage to Hell and Purgatory is depicted.

Biographical notes

Born in Rome in 1384, she dedicated her life to prayer and the assistance of the poor and was an exemplary wife and mother. She founded the Congregation of the Oblates of Mary and died in Rome in 1440.

Patronage

Invoked against the plague and for the liberation of souls in Purgatory; protector of car drivers and widows

Guercino, *Saint Frances of Rome*, Galleria Sabauda, Turin.

Joseph

Feast day: March 19

Appearance: usually a mature or elderly man in classical dress with beard

Attributes: flowering staff, child Jesus, carpenter's tools

The figure of Saint Joseph, whose cult came into being around the ninth century, was originally depicted as an old man, thanks in part to the influence of apocryphal texts. The saint was depicted in that way until at least the sixteenth century. According to the texts of the apocryphal Gospels, which provide details not found in the canonical Gospels, Joseph was chosen as the husband for the Virgin Mary from a group of suitors gathered in the temple. Each had been instructed to bring a staff and to direct a special prayer to God who would indicate the chosen one by making the staff flower. Joseph's was the only staff to flower, and so it has become his primary attribute in iconography.

Biographical notes
Joseph lived in the first century. He married the Virgin Mary and was chosen by God as the adoptive father for Jesus.

Patronage
Invoked for a good death and by the homeless and the exiled; protector of artisans, carpenters, woodworkers, supply officers, workingmen, fathers, and attorneys

Giovanni Serodine, *Saint Joseph*, 1620–30, church of Santa Maria della Concezione, Spoleto (Perugia).

Joseph

The most frequent iconographic narrations in which Saint Joseph appears illustrate the stories told by the Gospels, both canonical and apocryphal, concerning the infancy of Jesus: Joseph is a leading figure in scenes of the marriage of the Virgin, in the various episodes related to the Nativity and the Flight into Egypt, in the education of the young Jesus in the carpenter's workshop, and in the discovery of the twelve-year-old Jesus disputing with the doctors of the law in the temple, as well as many others. The sixteenth-century increase in devotion to Saint Joseph resulted in the creation of other scenes, including the death of Joseph, a scene witnessed by Mary and an adult Jesus, and delicate images of Joseph alone with the Child, whom he holds tenderly in his arms or takes by the hand.

Giovanni Battista Tiepolo,
Saint Joseph and Child, c. 1734,
church of San Salvatore, Bergamo.

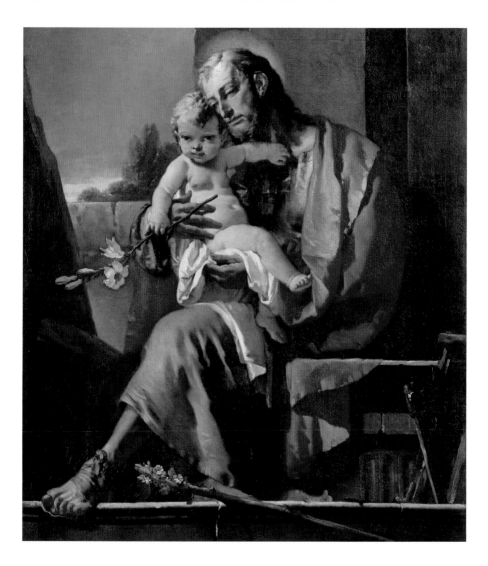

Francis of Paola

Feast day: April 2

Identifying situation: crossing the sea on his own habit, which is acting as a boat

Appearance: depicted with a long beard, wears the brown habit with a hood over his head

Attributes: staff topped by the word *charitas*, Tau-shaped staff, scourge, skull

Can be confused with: Franciscan saints

Biographical notes

Saint Francis was born at Paola, in Calabria, Italy, in 1416. After three years in a convent of the Friars Minor, he chose to live as a hermit by the sea, leading a life of prayer, fasting, work, and self-mortification. He was joined by followers who lived in a convent known as the Hermits of Saint Francis, later called the Minims, with a rule approved in 1506. He died in France in 1507.

Patronage

Invoked against conjugal sterility; protector of hermits

Out of humility toward Saint Francis of Assisi, Saint Francis of Paola called his brothers and the order he founded the Minims (*Minimi fratres*, "least brethren"), embracing the hermetic life. Because of the type of rule embraced, his image—in part similar to that of other Franciscans, dressed in the brown habit with the hood—was rendered unmistakable thanks to special attributes: the Tau-shaped staff (also an attribute of Saint Anthony the Abbot) and most of all the staff topped by the word *charitas*, often rayed or inserted in a sun but at times depicted on his chest or the cover of a book. In addition there are also the attributes common to hermits and penitents: the scourge and the skull.

Federico Benovich, *Saint Francis of Paola*, 18th century, church of the Santissima Trinità, Cremona.

Mary the Egyptian

Feast day: April 2

Appearance: woman in an attitude of prayer with hair so long it covers her body

Attributes: three loaves of bread, skull, lion

Can be confused with: Saint Mary Magdalen

The symbols of Saint Mary the Egyptian are all attributes of the penitent. According to medieval tradition, she lived many years as a prostitute in Alexandria, then joined a group of pilgrims going to Jerusalem where, following miraculous circumstances, she chose to return to God by leading the life of a hermit. She is usually depicted with extremely long hair that, again according to tradition, covered her body by the time her clothes had been worn away. The bread or loaves of bread often present in her images refer to what she took with her when she withdrew to the desert. She is sometimes shown with a lion, the animal that helped the monk Zosimus bury her when he found her dead. Depictions of Saint Mary the Egyptian receiving communion from Zosimus or from angels are common.

Biographical notes
Mary the Egyptian lived in the fifth century between Egypt and Palestine. She was a penitent hermit in the desert of Palestine.

Patronage
Protector of penitents

Jusepe Ribera, *Saint Mary the Egyptian*, 1641, Musée Fabre, Montpellier.

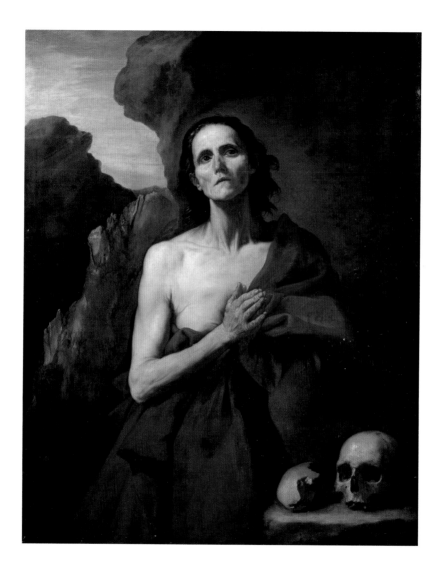

Vincent Ferrer

Feast day: April 5

Appearance: wears the white habit with black mantle of the Dominicans

Attributes: book, flame, dove, pair of large wings, baptismal font

Gesture: index finger pointing to the sky

Can be confused with: Saint Dominic

Recognition of Saint Vincent Ferrer, Dominican friar and preacher, begins with the white habit with black mantle of the order of which he was a member. He is usually illustrated with a book, most often open to display the legible words *Timete Deum et date illi honorem quia venit hora iudicii eius* (Revelation 14:7, "Fear God and give glory to him; for the hour of his judgment is come"), a synthesis of the subject of his preaching. Aside from the book, his iconography can include other symbols, such as a flame held in his hand that shines on his head, the dove symbolic of divine inspiration, in rare cases a baptismal font in memory of the many baptisms he performed, or a pair of wings since he was compared by the pope to an Angel of Judgment sent by God for the conversion of sinners.

Biographical notes
Vincent Ferrer was born in Valencia in 1350. A Dominican friar and preacher, he worked for the unity of the church during the period of the schism when there were two popes, one in Rome and one in Avignon. He died in Vannes, France, in 1419.

Patronage
Invoked against epilepsy, earthquakes, and lightning; protector of preachers and roofers

Colantonio del Fiore,
Saint Vincent Ferrer Polyptych,
c. 1460, Museo Nazionale
di Capodimonte, Naples.

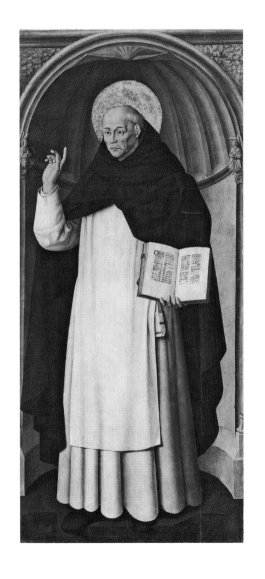

Vincent Ferrer

One of the most common methods of depicting Saint Vincent Ferrer is that in which he points his index finger toward the sky, a synthesis of his personality as a preacher and of the recurrent theme of his sermons. He announced the coming of the Last Judgment, and the skyward gesture was an invitation to direct one's gaze to Christ as judge and to the angels that will blow their horns on the day of the Last Judgment. This gesture is sometimes depicted in the closing image in a series.

Fra Bartolommeo, *Saint Vincent Ferrer*, 1512, Museo di San Marco, Florence.

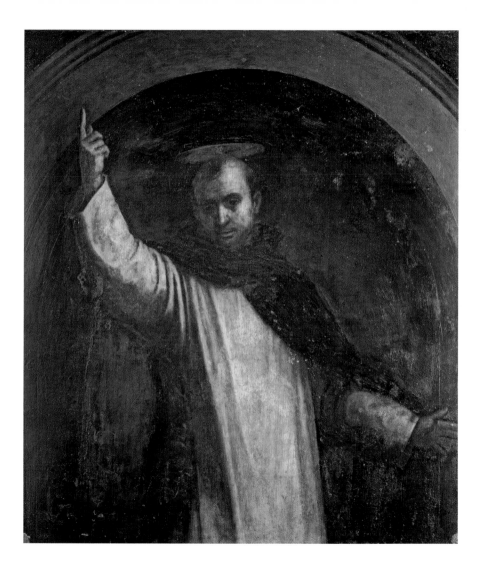

Peter of Verona

Feast day: April 6

Appearance: wears the white habit with black mantle of the Dominicans

Attributes: cleaver stuck in his head, dagger in his chest, palm branch, book

Can be confused with: Saint Thomas Becket, who wears bishop's vestments

The first saint of the Dominican friars, Saint Peter of Verona (Saint Peter Martyr) is always shown with the white habit and black mantle. His primary and unmistakable attribute is the cleaver stuck in his head; in some cases, however, it is replaced by a highly visible and deep wound in his tonsured (shaven crown) head. This iconographic attribute is based on his martyrdom, which he suffered near Como, not far from Milan. The heretics that ambushed him cracked his skull with a cleaver before stabbing him to death. Consequently, the image of this saint is sometimes completed by the presence of a dagger stuck in his chest. Also present at times are the palm branch and the book.

Biographical notes

Peter was born in Verona, Italy, in 1205. A Dominican friar and inquisitor, he died a martyr at the hand of heretics in 1252 near Milan.

Patronage

Invoked against headaches; protector of Dominicans, inquisitors, cloth merchants, shoemakers, and beer makers

Vittore Carpaccio, *Saint Peter Martyr*, 1514, Museo Correr, Venice.

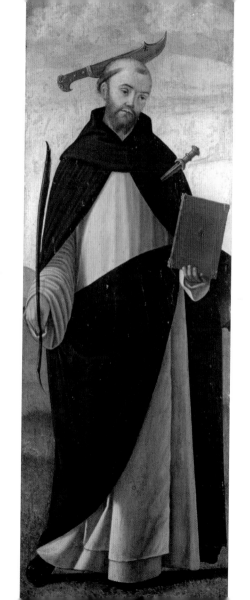

Zeno of Verona

Appearance: wears bishop's vestments

Attributes: fish, fishing gear

Can be confused with: Saint Andrew, who does not wear bishop's vestments

Thanks to the legend derived from the *Dialogues* of Gregory the Great, in which Saint Zeno is called the Fisherman of the Adige, the principal attribute of the bishop of Verona is fish hanging from a line and, sometimes, the transformation of the bishop's crosier into a fishing rod. This can be taken as a figural representation of his life. Since he was active in confronting the persistence of paganism and supporting the struggle against the Arian heresy, the image of the Fisherman of the Adige becomes a metaphor for the bishop as the "fisher of men." The saint's legends include the episode in which messengers from the emperor come to Verona seeking the miracle-performing exorcist bishop so that he could exorcise a demon from the body of the emperor's daughter; they found Zeno fishing on the banks of the river and received from him three fish just caught.

Biographical notes
Probably born in Africa in the early fourth century, he arrived in Verona, Italy, founded that city's first church in 362 and was bishop for ten years. He died in Verona in 372.

Patronage
Invoked against floods and to help infants speak and walk; protector of fishermen

Renato Birolli, *Saint Zeno the Fisherman*, 1932, Civico Museo d'Arte Contemporanea, Milan.

George

Feast day: April 23

Identifying situation:
knight battling a dragon to
free a princess

Appearance: knight or
mounted warrior

Attributes: dragon, princess

The story that serves as the basis for the unmistakable image of Saint George as a knight defeating a dragon is a medieval legend. The cult of the saint was approved by Pope Gelasius I in 494 and had already spread to England by the end of the seventh century, growing stronger during the Crusades. *The Golden Legend* proposed variants and new details, adding on to the medieval stories of Saint George, and these enriched the iconography of the saint often depicted on a white horse in reference to his spotless qualities. The dragon is said to have been wounded, tamed, and then led benignly through the lands it had previously terrorized, and the princess, who had been chosen to be sacrificed and held prisoner, is freed by the knightly saint.

Biographical notes
George lived between the third and fourth centuries and was martyred at Lydda in Palestine, where he was buried and his cult came into being.

Patronage
Invoked against skin diseases, plague, and venereal diseases; protector of halberdiers, arms-makers, knights, horses, soldiers, Boy Scouts, lepers, and the married men of Britain

Vitale da Bologna, *Saint George and the Dragon*, 1335–40, Pinacoteca Nazionale, Bologna.

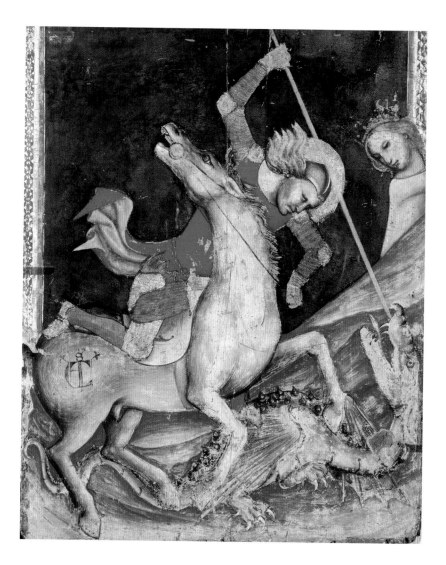

Mark

Feast day: April 25

Appearance: elderly man, usually bearded and wearing classical clothing

Attributes: book of the Gospels, winged lion

Although not one of the twelve apostles, Mark was a young disciple of Jesus and wrote the second of the synoptic Gospels in the year 70. As evangelist he is depicted writing or intently studying, accompanied by his symbol, the winged lion. Attributed to him by the Fathers of the Church and drawn from the Four Living Creatures presented in visions in the books of Ezekiel and Revelation, the lion was seen to correspond to Saint Mark since his Gospel begins with the figure of Saint John the Baptist withdrawing to the desert, and Mark's description of John crying out in the wilderness evoked the image of a roaring lion. The episode of his martyrdom, which according to the tradition supported by Eusebius of Caesarea took place at Alexandria, has not had a particular influence on Mark's image in art.

Biographical notes
Mark was a disciple of Jesus and an evangelist.

Patronage
Invoked for the harvest and against scabies; protector of notaries, opticians, glaziers, breeders, pharmacists, painters, shoemakers, tanners, secretaries, and interpreters

Giovenale Bongiovanni, *Saint Mark the Evangelist*, 18th century, cathedral of San Donato, Mondovì (Cuneo).

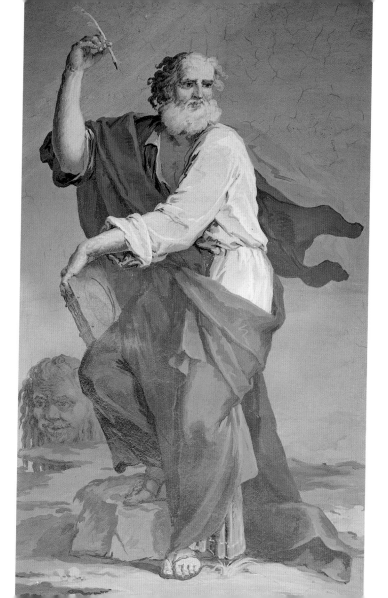

Mark

Following the translation (or transport) of the body of Saint Mark in the ninth century, when the remains of the saint were stolen from Alexandria and brought to Venice for the foundation of the new basilica, his cult spread in the West, beginning in Venice. From then on new iconographic depictions of the saint came into being, related to the miraculous events of the discovery of his remains, the translation of the body to Venice, and his various postmortem miracles. The episode of the discovery of Mark's mortal remains in the church of Saint Euphemia in Alexandria is described in some depictions with the apparition of the saint himself who, indicating that his body has been found, brings an end to the opening and consequent profanation of the other sepulchers while at the same time freeing a possessed person of the devil, proof of the veracity of his holy apparition.

Tintoretto, *Finding the Body of Saint Mark*, 1562–66, Pinacoteca di Brera, Milan.

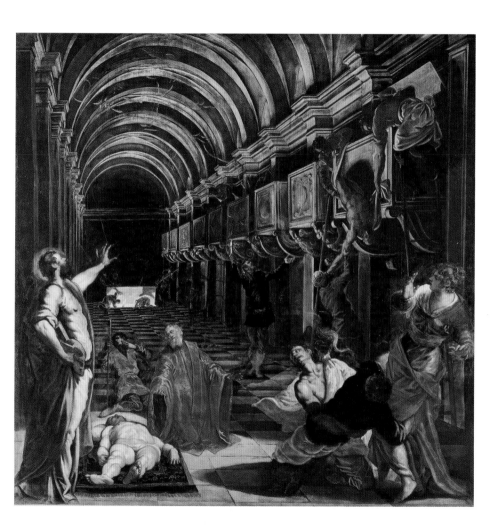

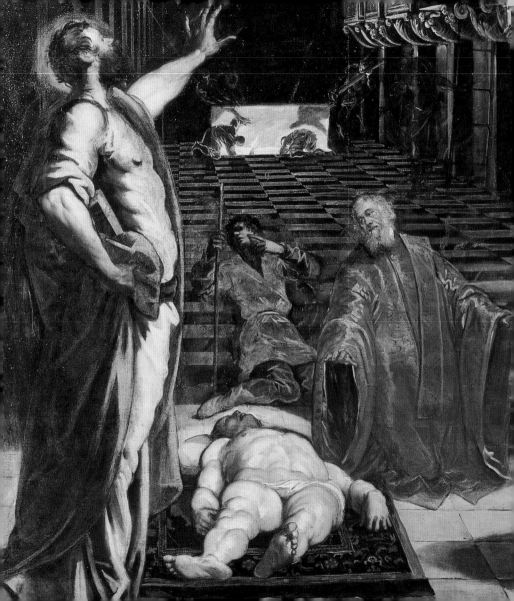

Catherine of Siena

Appearance: wears the
white habit and black mantle
of a Dominican nun; has the
crown of thorns

Attributes: displays the
stigmata and holds a cross,
lily, book, or heart

The twentieth daughter of Giacomo Benincasa, Catherine,
still very young, decided to remain a virgin and at eighteen
became a tertiary sister of the Dominican order. Because of
these two life decisions, the primary elements for her recog-
nition are the white habit with black mantle of a Dominican
nun and the branch of flowering lily. To these are added the
emblems of her complete self-identification with Christ: the
crown of thorns and the stigmata that Catherine received in
Pisa in 1375 from luminous rays given off by a crucifix made
by Giunta Pisano. Her mystical marriage to Jesus, a spiritual
experience she had in 1367, is also often encountered in
images. In some depictions, she holds a heart in her hand in
memory of her vision of Jesus, who removed his own heart
and exchanged it for hers. The book that often accompanies
Catherine is symbolic of her mystical knowledge.

Biographical notes
Catherine was born in Siena,
Italy, in 1347. As a Dominican
tertiary, she led a life of prayer
and penitence; she became
involved in the church's prob-
lems, exhorting the pope to
return to Rome from Avignon.
She died in Rome in 1380.

Patronage
Invoked against the plague,
migraines, and for a good death;
protector of nurses

Pompeo Girolamo Batoni,
*Ecstasy of Saint Catherine of
Siena*, 1743, Museo Nazionale
di Villa Guinigi, Lucca.

Philip

Feast day: May 3

Appearance: wears a tunic
and pallium

Attributes: cross, sometimes
a dragon, book

The primary iconographic attribute of the apostle Philip is
the cross that was the instrument of his martyrdom, which
according to tradition handed down in the apocryphal Acts
took place at Hierapolis in Phrygia, where Philip was cruci-
fied upside down and then stoned. Together with the cross,
which during the Middle Ages was usually somewhat small
but grew larger in depictions over the coming centuries,
Philip often holds a book—the primary distinctive emblem
of an apostle who followed Jesus, indicating the Word incar-
nate. Another attribute for this saint is a dragon, which
refers to the story told in *The Golden Legend* of how Philip
defeated the demon that dwelled among the idols.

Biographical notes
He lived during the first century.
A Galilean from Bethsaida, he
was one of the twelve disciples
chosen by Jesus.

Patronage
Protector of Luxembourg and
Uruguay

Georges de La Tour, *Saint Philip*,
1624, Chrysler Museum of Art,
Norfolk, Virginia.

Florian

Feast day: May 4

Appearance: depicted as a knight or soldier

Attributes: millstone or bucket of water

According to a seventh-century account of his martyrdom, Florian was a veteran of the Roman army who lived at Mantem near Krems. To show his solidarity with the Christians during the persecutions under Diocletian, he moved to Lorch, where he was arrested and thrown into the Enns River with a millstone around his neck. As a result of this, his early image was that of a Roman soldier with a banner; he was also sometimes depicted with the millstone with which he was drowned. First he was believed to be a protector against floods (and more broadly against the dangers of water), and later, with the spread of his cult, he was also thought to be a protector against fire. A bucket of water, an instrument used to put out a fire, was chosen as another attribute for him.

Biographical notes
He lived between the third and fourth centuries. He died at Lorch, Germany, during the persecution under Emperor Diocletian.

Patronage
Invoked against floods and fires; protector of firemen

Bartholomäus Zeitblom, *Saint Florian*, 1494, Staatgalerie, Stuttgart.

Job

Feast day: May 10

Appearance: old man covered with sores

Attribute: pottery shard (rare)

The first element for recognizing Job is his body covered with sores. In some instances a pottery shard is visible, that being the instrument with which the saint, stricken by the plague and showing a human weakness, scratched his wounds; the shard is a rare attribute in his iconography. As a reflection of his incredible misfortunes, he can be depicted atop a bed of cinders or a dung heap, interrogated and exhorted by his wife and three friends. Yet despite their constant preaching at him, his attitude is always one of peaceful resignation.

Biographical notes

Job lived around 1500 BCE in the land of Uz, today an area in Arabia or Jordan. A "perfect and upright man," at the moment of his greatest prosperity he was stricken with unspeakable misfortunes that deprived him of everything, including his health. Job managed to accept everything as the will of God.

Patronage

Invoked against leprosy and hypochondria; protector of breeders of silkworms

Albrecht Dürer, *Job Castigated by His Wife*; left panel of the Jabach Altarpiece (1503–04), Städelsches Kunstinstitut und Städtische Galerie, Frankfurt.

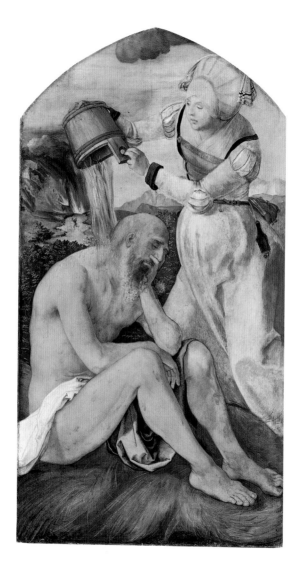

Isidore the Farmer

Feast day: May 15

Appearance: farmer

Attributes: agricultural implements, a bundle of grain, pair of oxen

This example of sanctity offered by a poor field hand, Isidore, known as "the Farmer," has been depicted by images of a man devoutly praying while in the field, his work being performed in his place by angels. The iconographic attributes of Saint Isidore are thus agricultural implements or a sheaf of wheat or a pair of oxen that pulls a plow led by angels. The various episodes that are part of his hagiography emphasize his generosity, which is always repaid by the Lord, who fills his bowl with soup after the saint has donated his portion to a poor man or makes his bundle of grain arrive intact even though during its journey Isidore had let a flock of starving birds feed on it.

Biographical notes
He was born in Madrid circa 1080. A poor field hand, he was devout and patient and died circa 1130.

Patronage
Protector of farmers and laborers

Francisco Ribalta, *Saint Isidore the Farmer*, late 16th century–early 17th century, Museo de Bellas Artes San Pio V, Valencia.

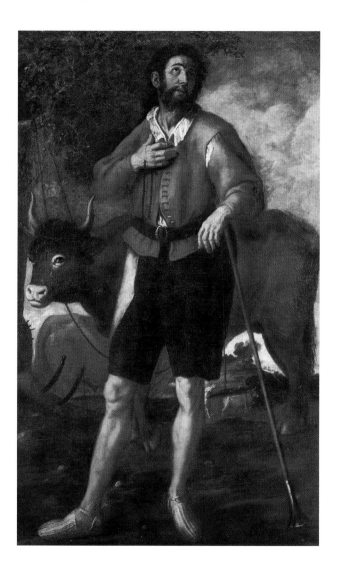

Simon Stock

Feast day: May 16

Appearance: wears the brown habit with scapular and white mantle of the Carmelites

Attributes: scapular, book of the rule, flame

The specific attribute for the recognition of Saint Simon Stock, always dressed in the brown habit with wide scapular (long band of cloth with an opening for the head) and sometimes a pale mantel, is a small scapular held in one hand or around his neck or being received directly from the Virgin or child Jesus. The latter presentation is based on the story according to which the Virgin appeared to him and gave him a scapular, promising that whoever was wearing it would be spared the pains of Purgatory. In reference to this revelation, among the attributes of Saint Simon Stock are flames, an allusion to Purgatory. The book of the rule is a symbol of the reform of the order performed by this saint.

Biographical notes

Perhaps originally from Kent, England, he joined the order of the Carmelite friars following a pilgrimage to the Holy Land. He helped reform the order's rule (it went from being a hermetic order to being mendicant) and was its sixth prior general. He died in Bordeaux, France, in 1265.

Patronage

Protector of the Carmelite order

Andrea Vicentino, *The Madonna Gives the Scapular to Saint Simon Stock*, early 17th century, Rovigo cathedral.

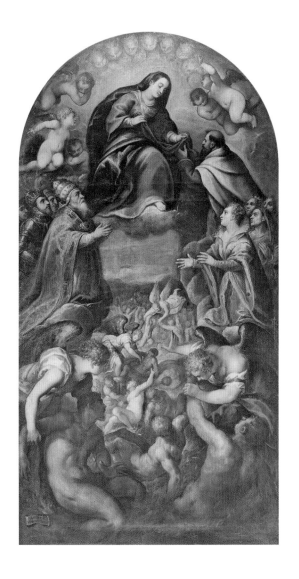

Yves

Feast day: May 19

Appearance: lawyer, scholar, judge, or cleric

Attributes: scroll or book

The images of Saint Yves illustrate the legal profession, practiced with rigor and charity for those—the poor, orphans, and widows—who cannot defend their rights. The object that has become his principal iconographic attribute is the scroll, meaning the scroll of petitions, or sometimes a book instead. The saint is usually depicted in the dress of a lawyer or judge. Saint Yves and his life story can be seen as a personification and an allegory of Justice.

Biographical notes
He was born in 1253 in Brittany, France, where he studied theology and canon law. After working as an ecclesiastical judge in the episcopal courts of Rennes and Tréguier, he became a priest and led an ascetic life. He died in 1303.

Patronage
Protector of lawyers, judges, jurists, magistrates, notaries, procurators, bailiffs, the poor, and the disinherited

French school, *Saint Yves*, 16th century, Musée de Picardie, Amiens.

Bernardino of Siena

Feast day: May 20

Appearance: dressed in the Franciscan habit with a weary expression

Attributes: the monogram of Jesus (IHS), three miters at his feet, a book

Saint Bernardino of Siena began his sermons holding up a wooden plaque on which he had written the letters IHS, the first three letters of the Greek name of Jesus and also the initial letters of the phrase *Iesus Hominum Salvator* ("Jesus, Savior of Men"). For this reason his principal iconographic attribute is the monogram of Jesus, around which the saint created a special cult. In addition to this attribute, there is the figure of the saint, whose appearance seems unmistakable and is derived precisely from his hagiography: promoter of the Observant branch, meaning the strict observance of Francis's rule, he lived a life of poverty and privations, which is usually indicated by his emaciated figure with a bony chin, pointed nose, and toothless mouth.

Biographical notes

Bernardino degli Albizzeschi was born at Massa Marittima, Italy, in 1380. A Franciscan priest, he was a resolute preacher of penitence. He died in 1444.

Patronage

Invoked against hemorrhage and hoarseness; protector of preachers, publishers, wool-workers, weavers, and boxers

Anonymous artist from Pavia, *Saint Bernardino of Siena*, 1485–90, Civici Musei d'Arte Antica, Castello Sforzesco, Milan.

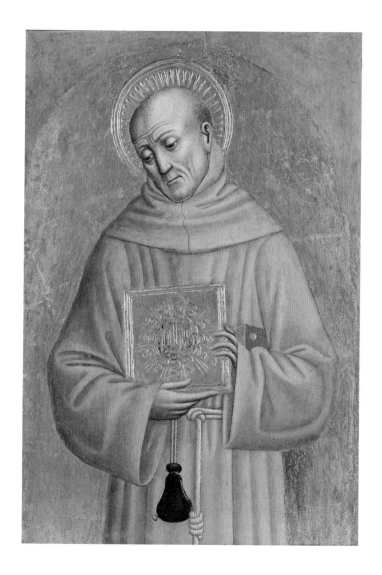

Bernardino of Siena

The Franciscan habit, often in the style adopted by the Observance (a grayish color in the oldest depictions), and clogs are characteristics of images of Saint Bernardino. Often added to these are three bishop's miters, never worn but positioned to one side, usually on the floor or the ground at his feet; they are there to represent the three bishoprics he refused, offered to him by the dioceses of Siena, Ferrara, and Urbino. The book he holds refers to the Observance of Francis's rule, but at the same time, it recalls that Saint Bernardino wrote theological treatises and battled the ignorance of friars by founding schools of theology.

El Greco, *Saint Bernardino of Siena*, 1603, Casa y Museo de El Greco, Toledo.

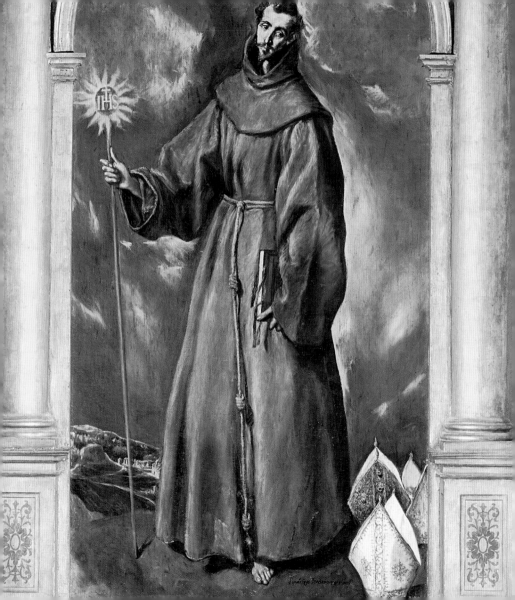

Rita of Cascia

Feast day: May 22

Appearance: wears the black habit of an Augustinian nun

Attributes: wound to forehead, crucifix, crown of thorns, bees, roses

Can be confused with: Saint Rose of Lima, who wears a similar habit and shares the attribute of roses but does not have the wound in the forehead

Biographical notes

She was born in 1381 near Cascia, Italy. Having lost her husband and children to a family feud, she retired to a convent, beginning a life of penitence and caring for the suffering. She died in 1457.

Patronage

Invoked against smallpox and natural calamities and by women desiring to have children; protector of grocers, pork vendors, and is the "patron saint of impossible causes"

The image of Saint Rita is closely tied to the penitent life that she led when she decided to withdraw to the monastery of Augustinian nuns at Cascia. The habit she wears is the black one of the order, and she is usually shown at prayer in front of a crucifix. Her desire to experience with Jesus the suffering of the cross was granted one day while she was at prayer when a thorn broke off Christ's crown of thorns and wounded her in the forehead; because of this, the wound—which never healed—and the thorn in the forehead became constant iconographic attributes. Together with these are the roses that sometimes appear in memory of the rose that miraculously flowered in her garden in the middle of winter after she had asked for one while sick; as soon as she had it she gave it to her sister nuns. The bees, which rarely appear, refer to an episode from her childhood when several bees surrounded the cradle where she slept without injuring her in any way.

Saint Rita, 19th century, church of Santa Maria del Giglio, Venice.

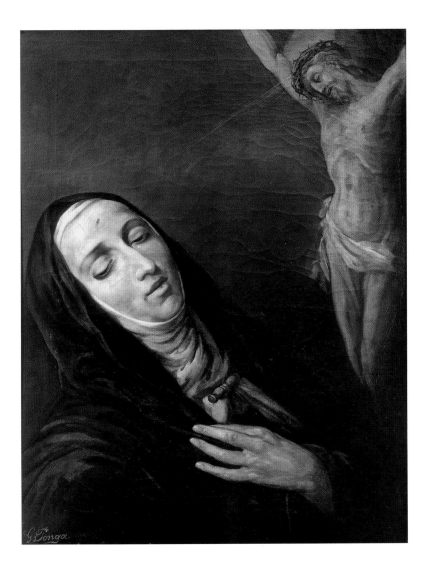

G. Tonga

Philip Neri

Feast day: May 26

Identifying situation:
kneeling in front of an altar
wearing a chasuble and
experiencing an apparition
of the Virgin and Child

Appearance: wears a priest's
robes with a long face and
white beard

Attributes: lily and book

Can be confused with: Saint
Ignatius of Loyola

The first artists to paint images of the sixteenth-century
priest Saint Philip Neri were familiar with his appearance,
for which reason his image is usually recognizable: An oval
face with thinning hair and a pointed white beard is the fig-
ure that art has handed down, even though Philip was not
fond of being portrayed so realistically. He said those who
had made drawings of him had "stolen" his image. The
attribute that is almost never absent is the branch of a flow-
ering lily, sometimes presented in his hand but most often
resting on the ground; to this can be added a book and in
rare cases an instrument of prayer, such as a crucifix or
skull. Saint Philip Neri always wears a priest's robes, the cas-
sock with white collar or a chasuble (the sleeveless outer
garment worn at Mass), especially if he is shown in adora-
tion of the Virgin Mary.

Biographical notes
Born in 1515 in Florence, he
became a priest in 1551 and
dedicated himself to the educa-
tion of the young men of the city,
using innovative methods that
joined the catechism to theater
and music. He founded the Con-
gregation of the Oratory in 1575.
He died in Rome in 1595.

Patronage
Invoked against rheumatism
and earthquakes; protector of
the young

Giovanni Battista Piazzetta, *The
Madonna Appears to Saint Philip
Neri*, early 18th century, church
of Santa Maria della Fava, Venice.

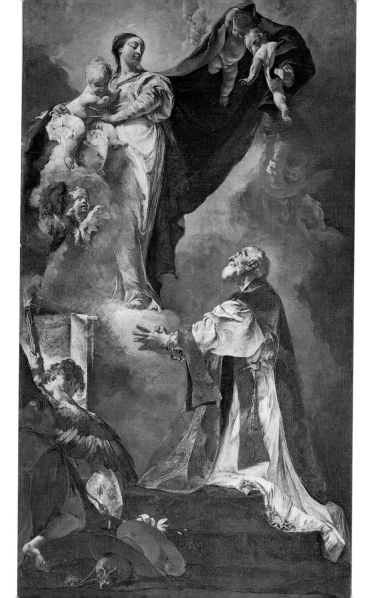

Joan of Arc

Feast day: May 30

Appearance: young woman in armor

Attribute: banner

A girl who went into battle inspired by the voices of saints, in so doing carrying out the will of God, is the extraordinary story that emerges from the image of Joan of Arc. Almost five centuries after her death on a pyre, having been found guilty of heresy, she was beatified and finally canonized. Her image has become reasonably widespread, most of all in France. The characteristic element of her image, aside from her armor and the fact that she is portrayed as a young girl (and thus without a helmet), is the presence of a banner in her hands. She is usually depicted with an inspired countenance, a sense of determination, her eyes fixed to the sky.

Biographical notes

Joan of Arc was born in Domrémy, France, around 1412. An illiterate peasant, at thirteen she heard the voices of saints calling on her to free France. She fought against the English and had Charles VIII crowned at Rheims. Betrayed and tried as a heretic, she was sent to the pyre in 1431. In 1455, the trial was annulled, and she was rehabilitated, but not until 1920 was she canonized.

Patronage

Protects telegraph and radio operators

Joan of Arc, miniature from *The Poetry of Charles d'Orléans*, 15th century, Centre Historique des Archives Nationales, Paris.

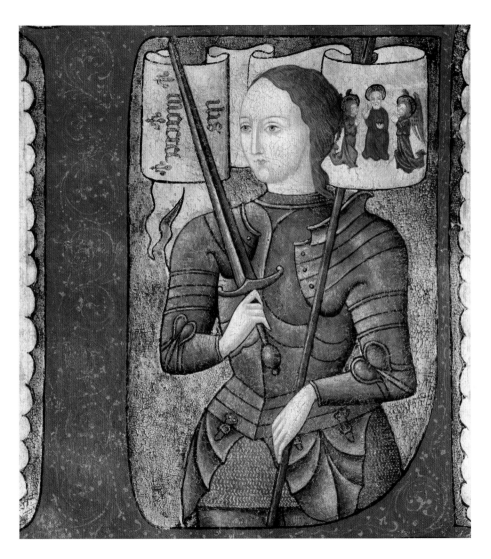

Erasmus

Feast day: June 2

Identifying situation: being tortured by evisceration using a windlass

Appearance: an older man

Attributes: windlass, bishop's insignia, palm branch

The actual events of the life of bishop Erasmus (Elmo) are related to his image only in terms of the clothing he wears and the bishop's insignia, along with the palm branch of martyrdom. Perhaps for his roving back and forth between Formiae in Italy and Mount Lebanon—between Sirmium (in today's Yugoslavia), Illyricum, and Gaeta (near Formiae), where he was martyred—or perhaps because his cult came into being at the seaside town of Gaeta, he was chosen without any concrete reason as the protector of sailors and soon enough was given an attribute related to naval equipment, a windlass. The cult of this saint spread over the course of the fourteenth century, by which time popular imagination made a connection between this attribute and an atrocious, but fictional, martyrdom: the evisceration of his intestines by means of a ship's windlass.

Biographical notes

Originally from Antioch, he became bishop of Formiae, Italy. To escape the persecution under Diocletian, he took refuge on Mount Lebanon. He was martyred at Gaeta around 303.

Patronage

Invoked against colic and labor pains; protector of sailors and fishermen in the Mediterranean

Unknown Dutch painter, *The Martyrdom of Saint Erasmus*, c. 1474, Society of Antiquaries, London.

Onuphrius

Feast day: June 12

Appearance: old man with long hair and beard

Attributes: crown, scepter, skull, cross, raven bearing bread in its beak

Can be confused with: Saint Paul Hermit, Saint Jerome

Saint Onuphrius's appearance immediately calls attention to the extraordinary decision he made at the age of sixty to retire to the desert and lead the life of a hermit. Thus he appears half-naked, covered by a few leafy branches, with long hair, a beard, and the features of an elderly man. His other attributes (not always present in depictions) indicate the life of wealth and power the saint left behind: the crown and sometimes also the scepter on the ground or to one side. Added to these specific elements are those typical of the life of penitence and prayer, such as the skull, cross, and rosary. The raven carrying bread in its beak (common to other hermit saints) is a reminder that Onuphrius was fed daily by that bird.

Biographical notes

Of noble origins, Onuphrius lived between the fourth and fifth centuries. At sixty, after living in the monastery of Hermopolis, he chose to live as a hermit in the Theban desert, where an angel brought him communion on Sundays and a raven brought him bread daily. He died in complete solitude around 400.

Patronage

Protector of fabric merchants and laborers

Francisco Collantes,
Saint Onuphrius, c. 1630,
Prado, Madrid.

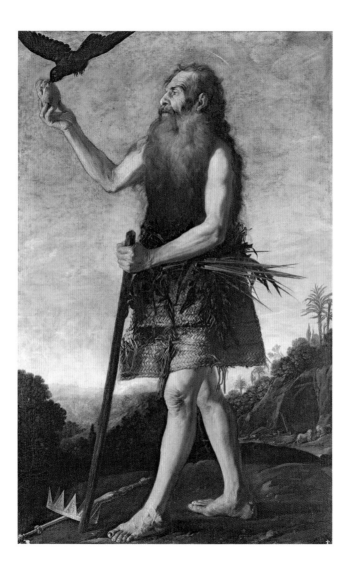

Anthony of Padua

Feast day: June 13

Identifying situation: holding the baby Jesus in his arms

Appearance: a young man wearing the Franciscan habit

Attributes: book, bread, flame, heart, lily, baby Jesus

The characteristic features of Saint Anthony of Padua are those of a youth wearing the Franciscan habit of the Observance. He is depicted with the flowering lily as a sign of purity and chastity, and he may appear in the company of a book to indicate his position as Doctor of the Church as well as a teacher in various European universities. The flame, symbol of the love for God, is present in the oldest images and can be explained by the fact that the iconographic elements of Saint Anthony Abbot have become associated with him. A heart may appear with the same meaning, while loaves of bread are an allusion to the saint's charity to the poor.

Biographical notes
Born in Lisbon in 1195, he became an Augustinian monk and in 1220 became a Franciscan. A preaching friar, he taught in several European universities. In Padua he dedicated himself exclusively to preaching. He died in 1231.

Patronage
Invoked to find lost objects and by women seeking husbands; protector of orphans, prisoners, shipwrecked persons, pregnant women, sterile women, sick children, glaziers, and conscripts

Alvise Vivarini, *Saint Anthony of Padua*, c. 1480, Museo Correr, Venice.

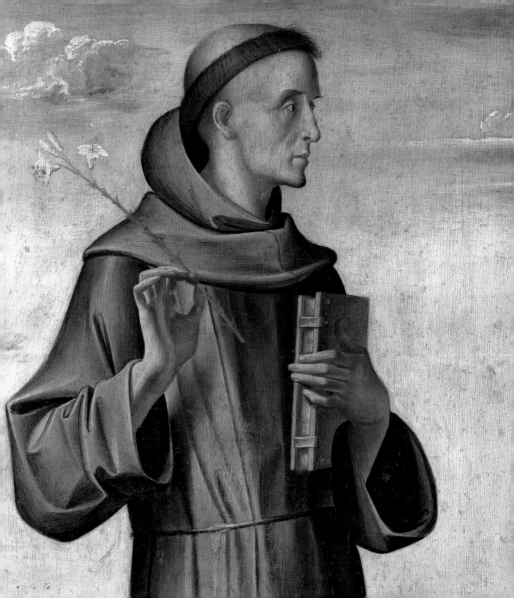

Anthony of Padua

Without doubt the baby Jesus, tenderly held in the saint's arms and sometimes seated atop a book or embraced, is the most unmistakable attribute of Anthony of Padua. The image is derived from a vision the saint had while a guest in the castle of Camposampiero outside Padua. On that occasion it happened that the owner, Count Tiso IV, aware that the saint prayed with great fervor and eager to get a look at him while he did so, peered through a window and saw Anthony with a beautiful baby boy that he contemplated and kissed. This was the baby Jesus, who revealed to the saint that he had been overseen by the count. At the conclusion of the prayer, Anthony called his host and asked him not to reveal anything of what had happened. Only after the death of the saint did the count tell the story.

Nicola Grassi, *Saint Anthony of Padua with the Baby Jesus*, 18th century, Civici Musei e Gallerie di Storia e Arte, Udine.

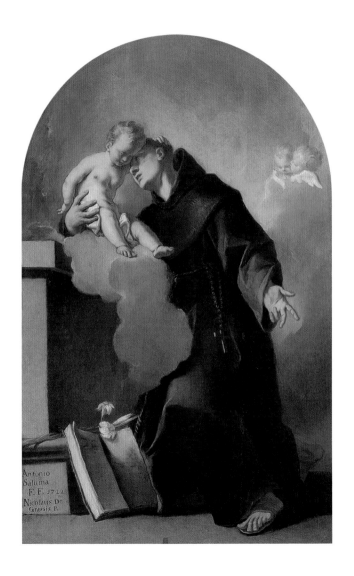

Vitus

Feast day: June 15

Appearance: youth or child

Attributes: white rooster, tub or pot, palm branch

Vitus is a difficult saint to recognize because his figure does not have a uniform iconography. In Italy he often appears as a youth, whereas in Germany he is a child. His legend, as presented in the work by Jacobus de Voragine, does not include sufficient elements to establish unquestionable attributes. Taking into consideration the possible variations of age, this saint can be identified by the presence of his two companions, the tutor Modestus and the nurse Crescentia, as well as by references to the numerous tortures he suffered, in particular that of the pot of boiling oil into which he was thrown. When Vitus was thrown into the pot, a rooster was also thrown in with him, which is why a rooster is another symbol of the saint.

Biographical notes

A young Christian of the third century, perhaps originally from Sicily, he worked miracles even in his youth. According to legend, he was assisted by two angels, his tutor Modestus, and his nurse Crescentia. He healed Diocletian's son of epilepsy but was tortured and killed for his refusal to sacrifice to the gods.

Patronage

Invoked against lethargy, the bite of poisonous animals, chorea or Saint Vitus's Dance; protector of actors, dancers, epileptics, and tinsmiths

Giovanni Fiammenghino, *The Departure of Saint Vitus*, 1625, Civici Musei d'Arte Antica, Castello Sforzesco, Milan.

Romuald

Feast day: June 19

Appearance: monk with long beard wearing the white cloak of the reformed Benedictines

Attributes: a ladder being climbed by monks, Bible, book of the rule, pastoral staff, cane, skull, a tempting devil, model of the Camaldoli monastery

The characteristics of the hermit and the monk blend in the iconography of Saint Romuald, much as this saint, with the foundation of the monastery at Camaldoli, succeeded in combining the two different approaches to spiritual life. The appearance of the hermit is accomplished with the long beard, while the monk aspect is achieved by the presence of the tonsure (shaven crown) and white habit of a monk. Since he was abbot of the monastery of Saint Apollinare at Ravenna for a certain period, Romuald's attributes include the abbatial staff, which alternates with the staff of a hermit. His iconography sometimes includes a ladder along which monks climb skyward, referring to a dream in which Romuald saw monks climb toward the sky, an allegory of the gradual ascent toward God. Sometimes, as a hermit, he is depicted being tempted by the deceptions of the devil.

Biographical notes

Romuald was born around 950 in Ravenna, Italy. A Benedictine abbot, he felt a strong need to combine the hermetic experience with the monastic and founded the Camaldolesian order in 1012. He died in Val di Castro, Italy, in 1027.

Patronage

Protector of the Camaldolesian order

Pseudo-Jacopino, *The Vision of Saint Romuald*, 1329, Pinacoteca Nazionale, Bologna.

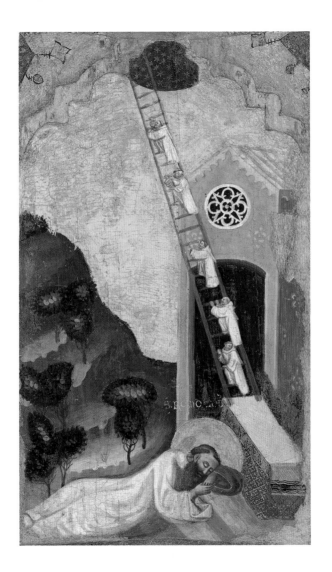

Aloysius Gonzaga

Feast day: June 21

Appearance: youth wearing clerical gowns with a white tunic over a black cassock

Attributes: crucifix, lily, skull, scourge

The crucifix held in the hands as source and inspiration of prayer is the primary iconographic attribute for Saint Aloysius (Luigi) Gonzaga, which is symbolic of an ascetic life. To this can be added the emblems of penitence: the scourge (on the ground or near him) and the skull. The branch of flowering lily is symbolic of chastity, alluding to the vow that the youth made at the age of ten. The clothing of a professed clergyman, with the white tunic over the black cassock but without a priest's stole, identifies him as a member of the Jesuit order.

Biographical notes

He was born in 1568 in Lombardy, Italy, into the noble family of the Gonzagas. At ten he made a vow of chastity and renounced his hereditary rights to enter the order of the Jesuits. He died of the plague in Rome in 1591.

Patronage

Protector of youths, scholars, students, and the Jesuit order

Giovanni Domenico Tiepolo, *Saint Aloysius Gonzaga*, 1760, Pinacoteca di Brera, Milan.

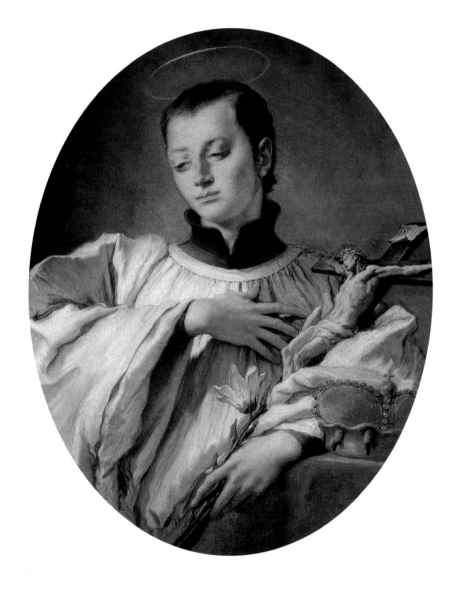

Aloysius Gonzaga

Depictions of Saint Aloysius from the period of his life before his choice of a religious career are somewhat rare. The most significant relates to his First Communion, which the saint received at the age of twelve. The episode is usually presented with great solemnity and drama since it has two protagonists, Aloysius and another great saint, the cardinal Charles Borromeo. Saint Charles had already had occasion to witness the devotion of the young Aloysius Gonzaga and in fact had been directly involved in his training up to the moment when he judged him ready to receive his First Communion. In the depiction of this episode, the family members of Saint Aloysius witness the sacrament as he prepares to receive the host from the hands of the cardinal saint.

Francesco Cairo, *Saint Aloysius Gonzaga Receives First Communion from Saint Charles*, 17th century, parish church, Casalpusterlengo (Lodi).

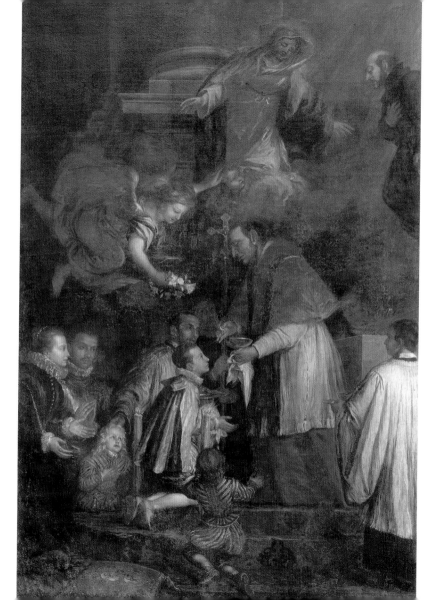

John the Baptist

Feast day: June 24

Identifying situation: baptizing Jesus in the Jordan River

Appearance: dressed in the poor tunic of a hermit; a baby or a young man

Attributes: lamb, cross

Gesture: points to Jesus or to the sky

Biographical notes

The son of Elizabeth and Zacharias, both already advanced in years, John was born about six months before Jesus. He chose the life of a hermit and preached conversion, baptizing in the waters of the Jordan. Jesus went to him to be baptized as well. He was killed by decapitation after having been imprisoned by Herod.

Patronage

Protector of hoteliers, cutlers, fowlers, tailors, and leather workers

The image of Saint John the Baptist is derived primarily from his description in the Bible (Mark 1:6), where his hermit's life is synthesized in the words "John was clothed with camel's hair, and with a girdle of a skin about his loins; and he did eat locusts and wild honey." The saint therefore was initially depicted as an adult with a simple tunic of skins or hide (sometimes also with a red cloak in allusion to his martyrdom). His primary attribute is a lamb, a reference to the phrase *Ecce Agnus Dei!* ("Here is the lamb of God!") that he exclaimed when he recognized Jesus, who had come to him to receive baptism. Another attribute is a long cross, often made of reeds, attached to which is a cartouche that also bears the phrase *Ecce Agnus Dei* or other phrases related to Saint John's preaching.

Giovanni Battista Piazzetta, *Saint John the Baptist*, early 18th century, Museo Civico, Bassano del Grappa (Vicenza).

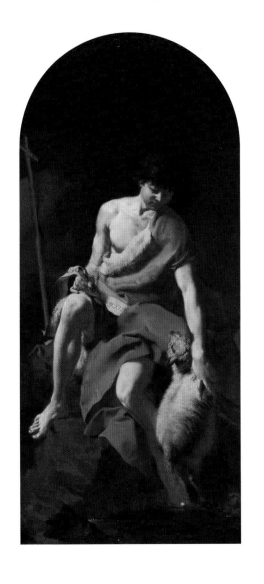

John the Baptist

Especially during the Renaissance, images of the young Saint John the Baptist enjoyed popularity. In such images, he is shown as a child but already bears the attributes of the adult saint: clothing made of furs or hides, a long cross made of reeds or sticks. In these cases, he is usually depicted in the company of the baby Jesus, the Holy Family, or Saint Elizabeth. According to an apocryphal tradition, on their return from the Flight into Egypt, the Holy Family traveled through the desert where the young John was already leading a hermit's life, and there the two cousins met for the first time. The image of the adolescent John began appearing around the end of the fifteenth century and became more popular over subsequent centuries. In such images the saint appears with his well-known attributes. Scenes from the life of John the Baptist include depictions of his preaching and his decapitation or, on occasion, only his head on a platter.

Sandro Botticelli, *Madonna and Child and the Young Saint John the Baptist*, 1495–1500, Galleria Palatina, Palazzo Pitta, Florence.

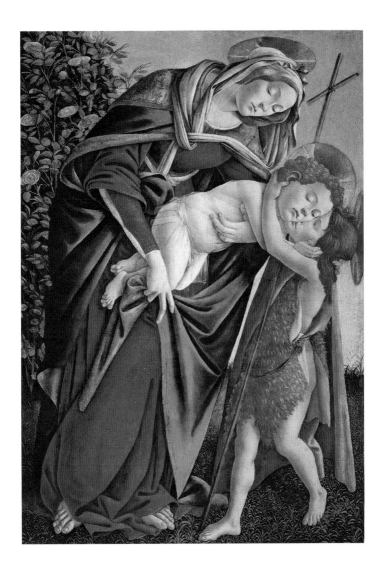

Paul the Apostle

Feast day: June 29

Appearance: thinning hair and a long, dark beard

Attributes: book, sword, basket

Together with Saint Peter, Paul was among the first saints of whom images were made, around the fourth century. His physiognomy had been established by the fifth century and underwent few substantial modifications over the course of time, based in part on the description given by the fourth-century church historian Eusebius of Caesarea, who described him as a man with a noble face, thinning hair, and a long, black beard. Paul's image also shows the influence of the standard typology of the philosopher, the iconographic model for which was probably Plotinus. Beginning in the thirteenth century, in addition to the book in the form of a scroll or codex, he was given the attribute of a sword—most often unsheathed—in reference to his martyrdom by decapitation instead of crucifixion, which he merited as a Roman citizen. Saint Peter in contrast was crucified. The basket that sometimes is depicted with Paul refers to his flight from Damascus, when he was lowered over the walls in a basket.

Biographical notes

A Jew born at Tarsus, he was a tent-maker and educated as a Pharisee. He took part in the persecutions against Christians until, while traveling on the road to Damascus, he had a vision that led him to convert. He was baptized and began preaching, founding several communities. He was executed in Rome around the year 65.

Patronage

Protector of theologians and the Catholic press

Segna di Bonaventura, *Polyptych with Saints John the Evangelist, Romuald, Paul, and Mary* (detail), 1298–1331, Pinacoteca Nazionale, Siena.

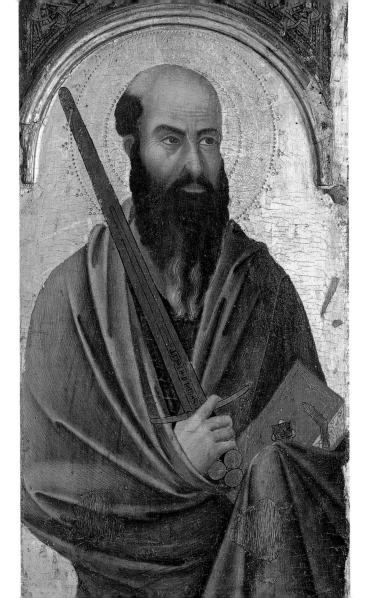

Paul
the Apostle

The book, depicted in the earliest images in the form of a scroll, later as a codex, held closed in half-hidden hands like a sacred object, or open, as an object for close study, is the primary attribute that was initially ascribed to Saint Paul. It is in reference to his stature as a philosopher of Christianity (and a man shown with a scroll is commonly accepted to represent a philosopher). At the same time, according to a Christian interpretation of the image, a written text being held indicated the Word—i.e., the Word incarnate, the Gospel—and as such this became the primary attribute of Paul as an apostle and disciple of Jesus. Over time it also acquired significance as a symbol of the many letters Saint Paul wrote to the Christian communities.

Diego Velázquez, *Saint Paul*, 1619, Museu Nacional d'Art de Catalunya, Barcelona.

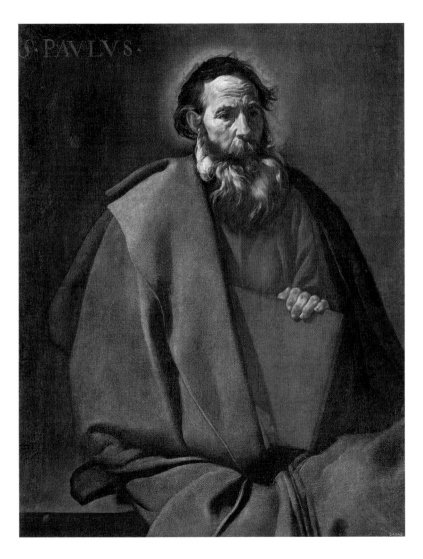

Peter the Apostle

Feast day: June 29

Appearance: dressed in a tunic and pallium, sometimes wearing papal robes; short curly hair; sometimes a tonsure; and a short curly beard

Attributes: keys, book, cock, boat, chains

Biographical notes
Simon, fisherman of Capernaum, was chosen by Jesus and called Peter (from the Greek *petrus*, "rock") to be the "rock" on which the church would be built. He preached his way to Rome, where he died under Emperor Nero between 64 and 67.

Patronage
Protector of fishmongers, fishermen, cobblers, keymakers, harvesters, watchmakers, and porters

The earliest images of Saint Peter, already characterized by short curly hair and a short curly beard, show the apostle wearing a tunic and short mantle. The earliest iconographic motifs reflected episodes from his life. First of all was the scene of his denial of Jesus, which early on resulted in the attribute of the cock being linked with Peter's identity (John 13:38, "I say unto thee, the cock shall not crow till thou hast denied me thrice") as an example of God's great compassion, entrusting his own church to a repentant apostate. Second, and probably the best-known symbol of Peter is the key which alludes to the episode of the consignment of the keys (*traditio clavium*) by Jesus to the apostle. The saint's appearance changed over the course of the Middle Ages, evolving to include papal robes. The boat as an iconographic attribute is present from the early Christian period: It alludes to the trade of fishermen and is also symbolic of the church. Chains are sometimes included as an attribute of Peter, emblematic of the imprisonment he suffered because of his preaching.

Saint Cecilia Master, *Saint Peter*, 14th century, Uffizi, Florence.

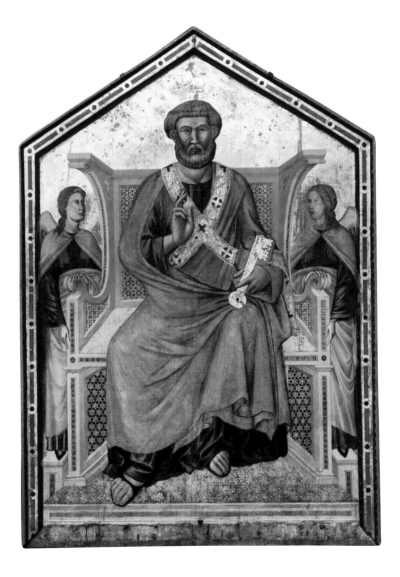

Peter the Apostle

Among the narratives that recount episodes in the life of Saint Peter, one of the most important is that which tells of his martyrdom. According to tradition, he was crucified, but since he did not consider himself worthy of dying like Christ he asked to be crucified upside down. If the Lord had descended to earth to be raised upon the cross, Peter, who by the grace of God had been called to the heavens, desired that in martyrdom his head would be directed to the ground and his feet to the sky. This ancient tradition is not related in the Acts of the Apostles but was handed down by *The Golden Legend*.

Filippino Lippi, *Quarrel with Simon Magus and Saint Peter's Crucifixion* (detail), from the Stories of Saint Peter, 1478–85, Brancacci Chapel, Santa Maria del Carmine, Florence.

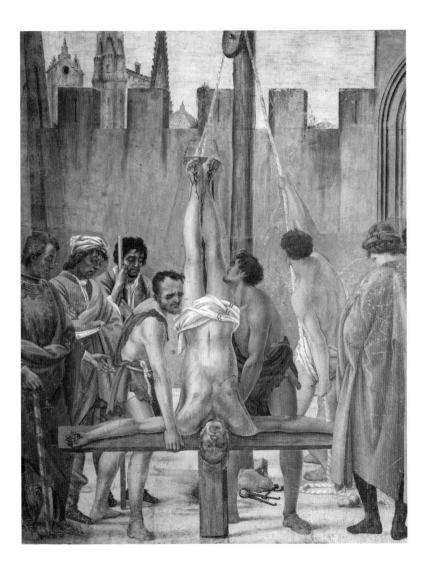

Thomas the Apostle

Feast day: July 3

Appearance: wears ancient dress

Attributes: book, carpenter's square, lance, belt or girdle

The doubting of Saint Thomas is the best-known and most recognizable image of this apostle, who is usually shown in mature age and most often in scenes of the divine manifestation that reinforced and supported his faith. The earliest images, which came into being around the tenth century, show Saint Thomas trying to touch the wound in the risen Christ's side; two centuries later the action of Jesus, who takes the apostle's hand and draws it toward the wound, appears in depictions. Images of Saint Thomas alone are not widespread, and the iconographic attributes related to his doubtfulness can also include a girdle or belt in reference to the episode of the Assumption of the Virgin to Heaven when, according to apocryphal narratives, Thomas was not present as a witness; he arrived later, and Mary let her girdle fall so that he would believe in her assumption.

Biographical notes

Thomas lived in Palestine in the first century and was an apostle of Jesus. In the Bible and apocryphal texts, he is described as suspicious and doubtful, but he believed immediately when faced with the manifestation of Jesus.

Patronage

Invoked against eye problems; protector of architects, artists, carpenters, engineers, masons, stonecutters, and judges

Master of Santo Domingo of Silos, *Incredulity of Saint Thomas*, 12th century, monastery of Santo Domingo, Silos.

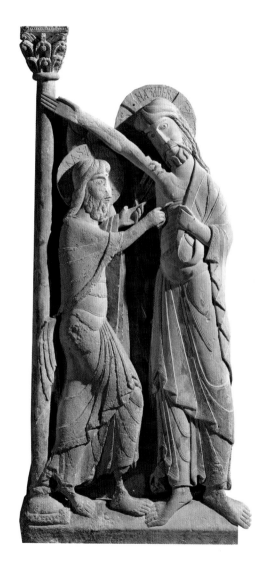

Thomas the Apostle

A carpenter's square was the first iconographic attribute given to Saint Thomas, chosen on the basis of apocryphal stories, repeated in *The Golden Legend*. According to these stories, the apostle had been invited by the king of India to come build a sumptuous palace, for which the ruler had made all his wealth available. The apostle went to the king and took the wealth only to donate it to the poor, declaring he had built a "Palace in Heaven." This affront to the king was pardoned only when the king's brother, who had died four days earlier, came back to life and reported having seen a marvelous palace erected for the king in Paradise because of the charity of his architect. According to the same source, Saint Thomas's mission to India ended when he was murdered by pagan priests, who attacked him with spears. As a result, in the seventeenth century, the spear became Thomas's most common iconographic attribute.

Georges de La Tour, *Saint Thomas*, 17th century, Louvre, Paris.

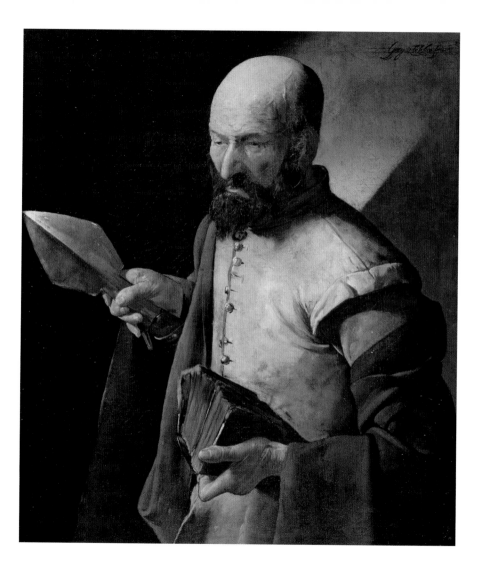

Elizabeth of Portugal

Feast day: July 4

Appearance: wears regal or monastic clothes

Attributes: flowers gathered in her skirt or (rarely) a pilgrim's staff

Can be confused with: Saint Elizabeth of Hungary, Saint Dorothy

Carrying flowers in a gathered skirt is an attribute of Saint Elizabeth of Portugal that is shared with Saint Elizabeth of Hungary (the two female saints have hagiographies that are in some ways similar), as well as with Saint Diego of Alcalá. This attribute alludes to the episode in which Elizabeth was carrying money hidden in the folds of her skirt to give away as charity, and she was surprised by the king (who was against such charity). He asked her what she was carrying, and when the saint revealed to him what she had in her skirt only roses and other flowers were found; hence the event is called the Miracle of the Roses. Another of Elizabeth's attributes is a pilgrim's staff, in memory of the one given to her by the bishop of Santiago de Compostela at the end of her pilgrimage there, after she donated her crown to the cathedral.

Biographical notes
Wife of King Diniz of Portugal, she lived from 1271 to 1336. She was a devoutly religious queen, always faithful to her marriage. Upon the king's death in 1325, she became a Franciscan tertiary and dedicated the rest of her life to prayer and care for the poor.

Patronage
Protector of the sick and winemakers, in memory of a miraculous transformation of water into wine

Francisco de Zurbarán, *Saint Elizabeth of Portugal*, c. 1640, Prado, Madrid.

Benedict

Feast day: July 11

Appearance: wears the black or white habit of a Benedictine

Attributes: book of the rule, abbot's crosier, raven with bread in its beak, chalice with serpent, rod or bundle of rods

Saint Benedict, abbot and monk, is distinguished by his monastic habit, which was originally very dark, even becoming black (until the spread of the Benedictine congregation of the Olivetans, who in 1319 adopted a white habit that thus also became a characteristic of images of Benedict). Other attributes are the abbot's crosier and the book of the rule, sometimes open to the first page with the words of the prologue: *Obsculta, o fili, praecepta magistri et inclina aurem cordis tui* ("Listen, O my son, to the precepts of the master, and incline the ear of your heart"). An unmistakable attribute is the bundle of rods, interpreted by some as the ability to join various precepts in a single rule; others see it as a sign of the strength of the rule and the severity of the saint. The raven with bread in its beak recalls an episode according to which a raven saved the saint by taking away a poisoned loaf.

Biographical notes
Born at Norcia in Umbria, Italy, around 480, he founded a form of monastic life based on liturgical prayer and manual labor, hence its Latin motto *Ora et labora* ("Pray and work"). He died in 547 in the abbey of Monte Cassino, which he had founded.

Patronage
Protector of farmers, Italian architects, chemists, peasants, engineers, and speleologists

Andrea Mantegna, *Saint Benedict*, from the Saint Luke Polyptych, 1453–54, Pinacoteca di Brera, Milan.

Bonaventure

Feast day: July 15

Appearance: wears a Franciscan habit, over which he wears bishop's vestments decorated with seraphic angels

Attributes: book, crucifix, angel, cardinal's hat (most often at his feet)

Although by no means an attribute specific to him, the identifying element for Saint Bonaventure is the Franciscan habit (gray or brown, tied at the waist by a cord with three knots representing the vows of poverty, chastity, and obedience), over which he wears bishop's vestments with the visible presence of a cardinal's insignia. He was nominated cardinal-bishop of Albano, but even earlier had been elected minister general of the order of minor friars. He is known as the Seraphic Doctor, and it is not unusual for the cloak he wears to bear decoration of seraphic angels. Among the attributes that most often appear with him is a book, an allusion to his theological studies, his teaching in the Franciscan school of Paris, and his numerous writings.

Biographical notes

Born around 1218 at Bagnoreggio near Orvieto, Italy, Giovanni di Fidanza took the name Bonaventure when he entered the Franciscan order. Elected minister general of the order, he played such a decisive role that he came to be called the "second founder of the order" and was nicknamed the Seraphic Doctor. In 1273 he was named cardinal-bishop of Albano. He died in 1274.

Patronage

Protector of theologians, messengers, porters, and weavers

Flemish Master, *Saint Bonaventure Cardinal with the Mystical Vine*, 15th century, Museo Francescano dei Cappuccini, Rome.

Bonaventure

The red, broad-brimmed cardinal's hat, another attribute of Saint Bonaventure, can appear not only atop his head but also abandoned on the ground or hanging from a tree trunk in memory of an episode handed down concerning the circumstances of his nomination. The papal messengers arrived while Saint Bonaventure was busy washing dishes in the friary, so he told them to set the hat aside and wait until he had finished. At the same time, the trunk on which the hat was hung makes reference to his treatise on the *Lignum vitae* ("Tree of life").

Vittore Crivelli, *Saint Bonaventure Holding the Tree of Redemption*, 16th century, Musée Jacquemart-André, Paris.

OPVS VICTOR CRIVELIV VENETII

Alexis

Feast day: July 17

Identifying situation: a man lying beneath or near a staircase

Appearance: a beggar or pilgrim

Attributes: staff, mat, stairs; sometimes holds a cross, but more often has a sheet of paper or a letter

Biographical notes

According to a medieval legend, the patrician Alexis lived between the fourth and fifth centuries; on his wedding night he left his wife and set off on a pilgrimage to Edessa, where he lived as a mendicant. Word of his sanctity spread, and he returned to Rome without being recognized by his family, who were waiting for him. He died as a beggar in his parents' home, where he had been living for seventeen years, sleeping under the stairs.

Patronage

Invoked by the dying; protector of beggars and porters

Bearing a name of Greek origin—*Alexis* means "protector," "defend by repulsing"—Saint Alexis is still included in the *Roman Martyrology*, even though all of his legend is probably of a later origin. Indeed, the fascinating legend from the medieval period is the source for the iconographic motifs used in depictions of this saint. His specific attributes are those of a pilgrim and a beggar: tattered garments, a staff, a mat for a bed. Most especially, a staircase can be taken as his distinctive attribute, in memory of the area under the stairs in his parents' home where he lived for seventeen years. To this can be added a piece of paper, in reference to the letter he grasped in his hand in which he had written his name so that, once dead, he could be identified.

Pietro da Cortona, *Death of Saint Alexis* (detail), c. 1638, Church of the Girolamini, Naples.

Margaret of Antioch

Feast day: July 20

Appearance: a young shepherdess

Attributes: dragon, crucifix

Can be confused with: Saint Martha, who along with the dragon has the aspergillum

According to her legend, the dragon that is the primary attribute of Saint Margaret of Antioch is in fact the demon that presented itself to her while she was in prison. The girl drove it away using the only weapon in her possession, a crucifix, and along with the dragon and the palm leaf, the crucifix serves to identify her. In general, her noble origins, handed down in medieval legends and collected in *The Golden Legend*, have not influenced this young martyr's image, preference being given instead to her depiction as a shepherdess—recalling that, while caring for her sheep, she was seen by the prefect Olybrius, who was so smitten by her beauty that he asked her to marry him, provided she was of noble birth. But the young woman, although indeed noble, had consecrated herself to God, and confessing her Christian faith she rejected him. His response was to report her, and she was tortured before her martyrdom by decapitation.

Biographical notes

Margaret of Antioch lived between the third and fourth centuries and was martyred in the 300s during the persecutions under Diocletian.

Patronage

Invoked by the dying and against storms; protector of pregnant women, teachers, farmers, and soldiers

Anonymous Spanish school, *Saint Margaret of Antioch*, 15th century, Musée Municipal, Gap.

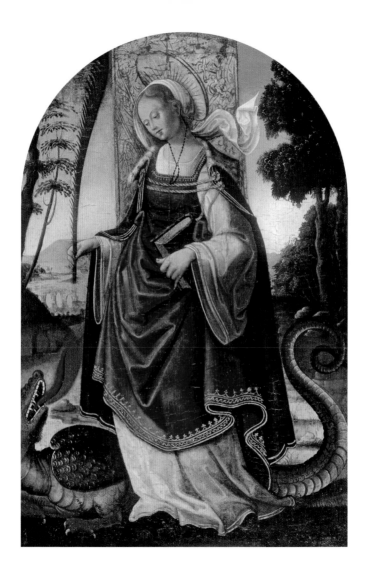

Mary Magdalen

Feast day: July 22

Appearance: often dressed in red; wears elegant clothes or appears hardly clothed if presented as a penitent; long, loose hair

Attributes: ointment jar, skull, crucifix, scourge as penitent

Can be confused with: Saint Mary the Egyptian

The iconography of Mary Magdalen follows the interpretation of Gregory the Great, who identified in the saint two women of the Bible: the sinner who asks pardon of Jesus in the home of Simon the Pharisee, washing his feet with her tears, drying them with her hair (hence the image of the long, loose hair), and anointing them with precious ointment (hence the attribute of the ointment jar); and the sister of Martha of Bethany, who anointed Jesus with perfumed unguent six days before the Passion. She was the first witness of the Resurrection, having gone to the tomb with other women to anoint the body of Jesus. Over the course of the Middle Ages preference was given to the sinner who brought the jar of ointment. She is often dressed in red in allusion to her sin.

Biographical notes

Mary Magdalen lived in the first century and was a disciple of Jesus. She is identified as two women of the Gospels: the sinner who asked pardon of Jesus, becoming his disciple; and the woman who performed the anointing of Bethany and who was the first witness of the Resurrection.

Patronage

Protector of gardeners, perfumers, glove-makers, and the penitent

Ambrogio Lorenzetti, *Saint Mary Magdalen*, early 14th century, Pinacoteca Nazionale, Siena.

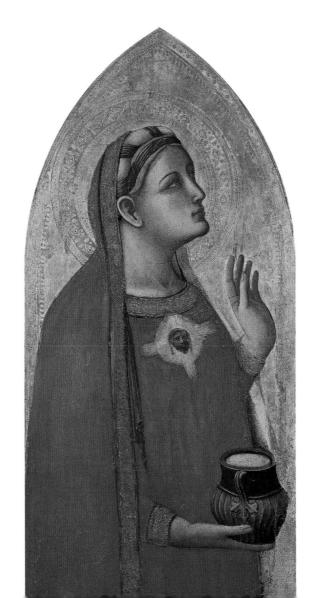

Mary Magdalen

The iconography of the period that followed the Council of Trent, the sixteenth-century meeting of the leaders of the Roman Catholic Church, showed a preference, in depictions of Saint Mary Magdalen, for emphasizing the figure of the penitent—making use of the legend according to which, together with her brother Lazarus and sister Martha, she evangelized Provence and later chose to live in solitude in the woods of that region. From this legend spread the image of Mary Magdalen as a disheveled or naked woman, with very long, loose hair, in ecstatic prayer before a crucifix and accompanied by such attributes as a skull and scourge, a book, and sometimes an hourglass or candle.

Guido Reni, *The Penitent Magdalen*, 1631–32, Galleria Nazionale d'Arte Antica, Palazzo Barberini, Rome.

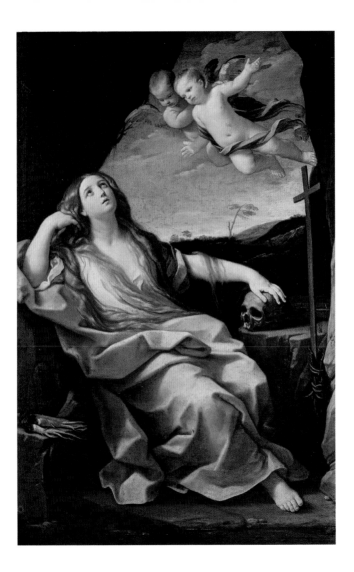

Bridget of Sweden

Appearance: an abbess, noble widow, pilgrim, sometimes with the cross of the Bridgettine order

Attributes: crown, lit candle, pen and inkwell, the monogram of Jesus (IHS), heart with cross

Biographical notes
Born in Uppsala in 1303, at fourteen she married the noble-man Ulf Gudmarrson, with whom she had eight children. Widowed, she dedicated herself to an ascetic and contemplative life; she became a Franciscan ter-tiary and founded a new order (Bridgettines), male and female, dedicated to the Holy Savior. She died in Rome in 1373.

Patronage
Protector of pilgrims and travelers

Saint Bridget, exemplary wife and mother, is usually depicted in the nun's habit that she adopted following the death of her husband. Her distinguishing element is a crown worn atop the veil, to which various other attributes can be added, such as a book, pen, and inkwell—all objects that refer to the dictation of the revelations she experienced. Another of her emblems is a heart with a cross, which according to tradition is how her heart was found to be after her death. The monogram of the name of Jesus, IHS, is a reference to the foundation of the Order of the Holy Savior, and the lit candle is in memory of the penance the saint inflicted on herself every Friday, pouring wax on her hands. In some depictions, she is shown holding two cartouches, one in her right hand and one in her left, indicating the two rules—one for the women, the other for the men—in the monastery she founded.

Saint Bridget of Sweden Gives a Message from Christ to a Bishop, miniature from the *Celestial Revelations of Saint Bridget of Sweden* (the *Liber Celestis*), c. 1410, British Library, Ms. Cotton Claudius B.I., fol. 117, London.

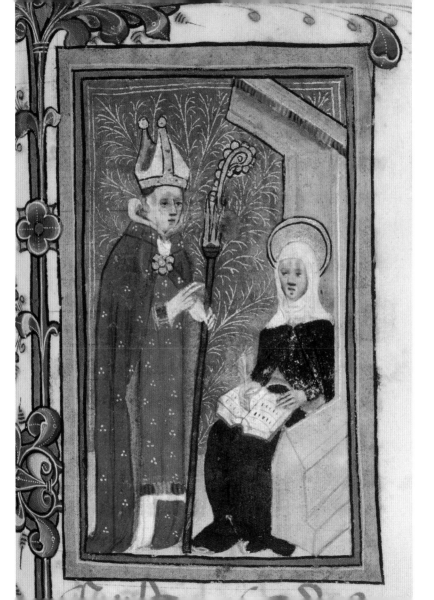

Christina of Bolsena

Feast day: July 24

Appearance: a young woman

Attributes: knife, arrows, millstone, palm branch

Can be confused with: Saint Agatha or Saint Ursula, whose attributes also include arrows

Included among the figures of female saints in the mosaics in Saint Apollinare Nuovo in Ravenna, Saint Christina does not have a single legendary tradition, for which reason a period went by in which the saint was thought to have lived in two very different locales. She was probably a young Christian originally from Tyre in Phoenicia but also was highly venerated at Bolsena in Italy, where she is said to have been martyred. Numerous legends developed around her person, drawing on the lives of other martyr saints, including Barbara and Agatha. The result has been iconographic variety as well as a wide choice of attributes with such range that determining the identity of this saint with any certainty is not easy. Lances, arrows, and other weapons are attributed to her because of the tortures she is said to have undergone. Also included is the millstone that is said to have been tied around her neck to drown her; this episode is the reason she was later recognized as the protector of millers.

Biographical notes
Christina, probably originally from Tyre, died in 287, during the persecutions under Diocletian.

Patronage
Protector of millers

Jacobello del Fiore, *Saint Christina*, early 15th century, church of San Giovanni in Bragora, Venice.

Christopher

Feast day: July 25 in West, May 9 in East

Identifying situation: fording a river while carrying the child Jesus on his shoulders

Appearance: large man; in Eastern iconography he sometimes has a dog's head

Attributes: child Jesus, palm branch or flowering staff

Biographical notes
He was martyred in Lycia in Asia Minor during the third century, probably under Emperor Decius.

Patronage
Invoked against the plague, sudden death, hurricanes, and hail; protector of car drivers, boatmen, railway workers, mountain climbers, porters, dockworkers, pilgrims, travelers, athletes, fruit vendors, and gardeners

This saint's unmistakable image dates back to the legendary deeds of a Christopher whose cult is attested to in Bithynia as early as the fifth century. According to tradition, he was a Canaanite of gigantic stature who decided to put his power in the service of the most powerful being on the earth. He served a great king until he learned the king was afraid of the devil, then served the devil until he realized the devil was afraid of Christ. Disillusioned he turned to a hermit who suggested he offer his services by ferrying travelers across a river. Doing this, still according to the legend, he served Jesus. One night he carried across a child who became heavier and heavier with each step and in the end revealed himself as Christ. As proof of this miraculous encounter, Christopher's staff, planted in the ground, put forth flowers.

Domenico Maggiotto, *Saint Christopher, Saint James the Greater, and Saint James the Less*, 1769, church of Santo Stefano, Treviso.

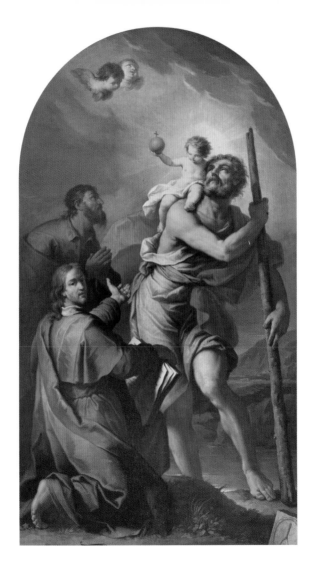

Christopher

According to the tradition provided by ancient Eastern texts of the life of Saint Christopher, his name was originally Reprobus, but he changed it after transporting the child Jesus, becoming the "bearer of Christ" (*Christopher*). He was said to have been a soldier in a rough tribe that included cannibalism among its primitive customs. Before meeting Christ and undergoing the experience of conversion, baptism, and the work of evangelism that ended with his martyrdom, the future saint had been a truly wicked man. The ancient texts go so far as to describe him as a "man with the head of a dog." This image is still found in the Eastern tradition, although it is said to be the result of Christopher having asked God to give him such a horrible face that he would escape all temptation.

Byzantine painter, *Dog-headed Saint Christopher*, 1685, Byzantine and Christian Museum, Athens.

James the Greater

Feast day: July 25

Appearance: a pilgrim or on horseback while defeating Moors

Attributes: pilgrim's staff, hat, seashell, book, sword (sometimes)

Biographical notes
The son of Zebedee and brother of John the Evangelist, James was an apostle of Jesus and one of the witnesses of the Transfiguration of Christ and his agony in the garden of Gethsemane. He was martyred under Herod Agrippa around 42.

Patronage
Invoked against rheumatism and for good weather; protector of milliners, pharmacists, druggists, sock-makers, and pilgrims

Alongside the customary image of the apostle wearing a tunic and mantle and holding a book, in the case of Saint James the Greater, the saint's iconographic depiction often differs not only for the addition of a specific item (in this case the pilgrim's staff) but also in the type of clothes he wears, enriched with the garb and belongings typical of someone setting off on a pilgrimage during the Middle Ages. This enlarged iconography is a result of the figure of Saint James the Greater having assimilated much of the appearance of his devotees, who following the diffusion of the cult of the saint went on pilgrimages to the sanctuary of Santiago de Compostela dedicated to him and the site of his tomb. As a result, Saint James sometimes has a pilgrim's staff, a gourd that was used as a canteen, a knapsack, a broad-brimmed hat, a cape on his shoulder, and the seashell of Santiago, the badge worn by those who had made the pilgrimage to that site.

El Greco, *Saint James the Greater*, 1580, Museum of Santa Cruz, Toledo.

James
the Greater

Saint James is also recognized in an equestrian iconography that appeared after the images of the saint as apostle and as pilgrim. In this later image, the saint rides a white horse while defeating Moors in battle; he holds a sword and sometimes a banner. Such images of the saint began to spread following the miraculous appearance of Saint James during the battle of Clavijo (844), a vision that turned the battle in favor of the Christians and led to the defeat of the Moors. This image is said to be of Saint James *Matamoros* ("Moor-slayer"), and in Spain, where it came into being, it was probably influenced by depictions of the emperor Constantine defeating pagans.

Castilian school, *Saint James Matamoros*, retable (detail), Royal Chapel of the Alcázar, Segovia.

Anne

Feast day: July 26

Identifying situation: busy
in the education of the Virgin
as a baby

Appearance: elderly woman

Attribute: the baby Mary

Saint Anne's cult has been known since the sixth century. Her
name is the fruit of an apocryphal tradition and does not
appear in canonical writings. The events that involve the
mother of the Virgin, and the iconography based on them, are
directly tied to Mary: the stories that precede her conception
(extraordinary for such an elderly couple), the birth of Mary,
her infancy, and her education. Anne is made recognizable
primarily by the presence of Mary as a child at her side in
scenes in which the older woman teaches and instructs her
daughter; Anne also appears with her husband, Joachim.

Biographical notes
Anne lived around the first
century in Palestine.

Patronage
Protector of sculptors, rag-sellers,
launderers, embroiderers, tailors,
navigators, illuminators, carders,
goldworkers, and makers of lace,
socks, gloves, and brooms

Anne Teaching the Virgin to Read,
from the *Breviary of John the
Fearless and Margaret of Bavaria*,
c. 1406, British Library, Ms. Harley
2897, fol. 340 v., London.

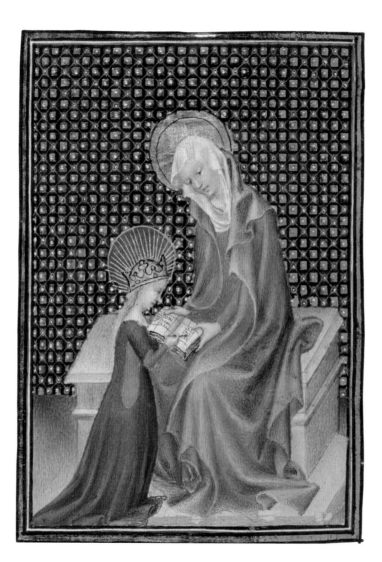

Martha

Feast day: July 29

Appearance: sometimes wears homely garb

Attributes: bucket and aspergillum or utensils for the care of a home, a dragon

Can be confused with: Saint Margaret of Antioch

Following the spread of the cult of Saint Martha, which came into being in Provence after the discovery of her presumed relics in the twelfth century, her image came to be defined on the basis of the apocryphal tradition of her life. Martha was said to have gone to Provence with Lazarus and Mary Magdalen, where she drove away a terrible dragon that infested the woods of that region. All she used to frighten off the monstrous creature was holy water that she spread with an aspergillum. On the basis of this legendary story, Saint Martha has as iconographic attributes a bucket and an aspergillum along with a dragon tamed at her feet.

Biographical notes
Martha lived in the first century and was the sister of Lazarus and Mary.

Patronage
Protector of housewives, maids, servants, cooks, and hospital dieticians

Bernadino Luini, *Saint Martha*, 1515–20, Pinacoteca di Brera, Milan.

MARTHA

Martha

The images of Martha holding a household utensil are based on a reading of the Bible, specifically the passage in Luke 10:40 in which Martha asks Jesus to get her sister Mary to help her with the household work.

Saint Martha, miniature from the *Breviary of Isabella of Castile*, c. 1497, British Library, Ms. Additional 18851, fol. 417 r., London.

Ignatius of Loyola

Feast day: July 31

Appearance: wears the dress of a clergyman or priest

Attributes: heart pierced by spines, the monogram of Jesus (IHS), the motto *Omnia ad maiorem Dei Gloriam* ("Everything to the greater glory of God")

Saint Ignatius's features are known from contemporary portraits and depictions, so the primary means for identifying him is his actual appearance, his oval face with the short, dark beard and his thinning, dark hair. Saint Ignatius is often depicted as a regular clergyman, wearing a black cassock with the collar of his white shirt visible in keeping with the style of the time. In some cases, he is shown wearing liturgical vestments, a white shirt, and a priest's chasuble (the sleeveless outer garment worn at Mass). For his ardent love of Jesus, and for having founded a religious order whose name refers to Jesus, the monogram IHS has also become his attribute.

Biographical notes
Born in 1491, he undertook a military career but was wounded in battle and began his conversion. After long preparation, with several followers he took vows of poverty and chastity to serve the church with preaching. He founded the order of the Society of Jesus (Jesuits), approved in 1540. He died in Rome in 1556.

Patronage
Invoked against evildoers and wolves; protector of the Jesuits and soldiers

Alonso Vázquez, *Apparition of Christ to Saint Ignatius of Loyola* (detail), 1508, Seville cathedral.

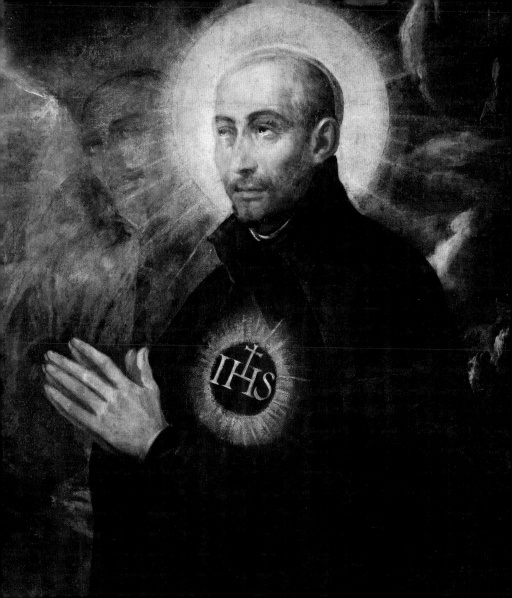

Cajetan

Feast day: August 7

Appearance: dress of a clergyman

Attributes: winged heart, flowering lily, book, skull, rosary crown

Biographical notes

Tommaso de Vio Cajetan was born in 1480 at Vicenza, Italy, and founded a congregation of ecclesiastics, the Clerics Regular, known as the Theatines, for the purpose of restoring the values of apostolic life to the clergy; it was approved by Pope Clement VII. He founded houses of the congregation at Naples and Venice, promoting charitable works and dedicating himself to his mission among the poor. He died at Naples in 1547.

Patronage

Cajetan is protector of the congregation of the Theatines.

A clerical habit, most often with a white surplice or shirt over the black cassock and in some cases completed by a stole, is the first element in identifying Saint Cajetan, founder—together with Bishop Pietro Carafa (future Pope Paul IV)—of a congregation of regular clergy. The spread of his image followed his canonization, which took place in 1671 (under Pope Clement X). His most common attributes include the symbols of prayer and penitence typical of the seventeenth century: the book, the skull, and sometimes the rosary. Saint Cajetan may also be depicted with a lily branch in flower and receiving the child Jesus from the Virgin or from Saint Joseph. Another common attribute is a winged heart, symbolizing a soul given to God, because he is known as the hunter of souls.

Francesco Solimena, *Saint Cajetan in Glory*, c. 1725, church of San Gaetano, Vicenza.

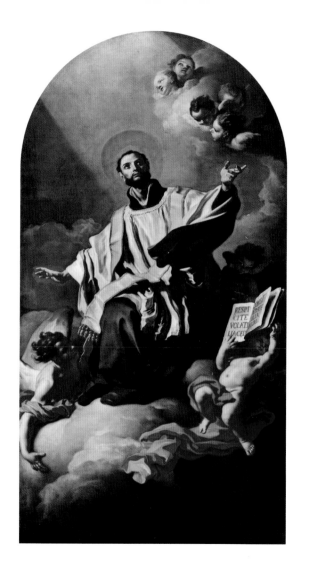

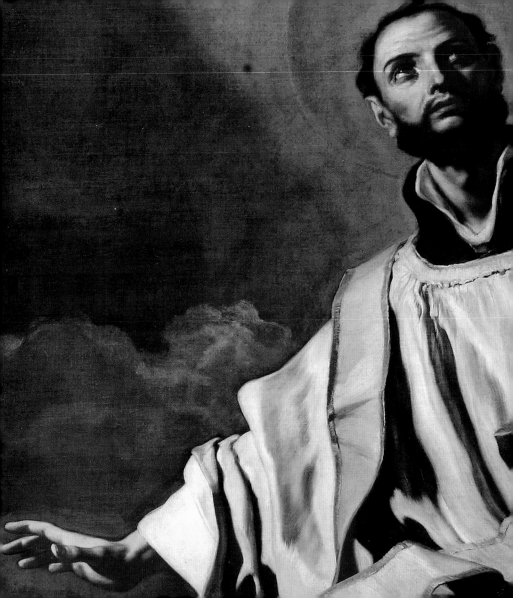

Dominic

Appearance: wears the white habit and black mantle of the Dominicans

Attributes: star on his forehead, lily, dog with a torch in its mouth, book

Biographical notes
He was born around 1170. Understanding the importance of reconciling heretics to the church, he founded the Order of Friars Preachers, once known as the Black Friars and best known as the Dominicans, and dedicated himself to the education of the clergy, as well as creating communities and culture centers. He died in 1221.

Patronage
Protector of astronomers, orators, and seamstresses

A white habit with large scapular (long band of cloth with an opening for the head) and black mantle, a tonsure (shaven crown), and a usually clean-shaven face are common characteristics of the appearance of Saint Dominic. Dominic almost always carries a flowering lily, symbol of chastity, and has a book that indicates his devotion to a rule (that of Saint Augustine, to which he added specific statutes for the new religious order). He often appears with a star shining from his forehead, a symbol of wisdom. In later representations he may be accompanied by a black-and-white dog holding a torch in its mouth, in reference to a dream his mother had before he was born—a dream interpreted later as a prophecy that the child would inflame the world with his words. According to some the dog can be explained by assonance with the name of the order, *Dominicanus* (*Domini canis*).

Pedro Berruguete, *Saint Dominic*, c. 1500, Prado, Madrid.

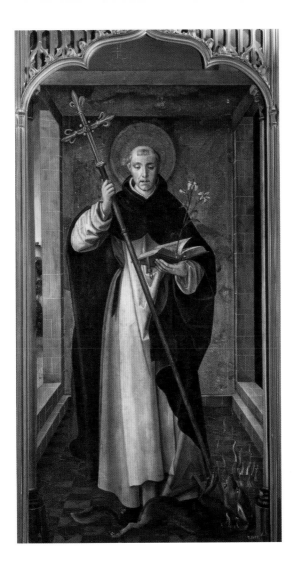

Dominic

Several special images of Dominic show him kneeling in front of the Madonna and Child, who are usually seated on clouds or enthroned, receiving a rosary. The Dominicans were great promoters of Marian prayer using the rosary and, from the end of the sixteenth century, they spread the tradition according to which, in 1210, Dominic had had a vision of the Virgin and Child giving him the rosary as an instrument of prayer to defeat heresy. In truth, prayer with the rosary began spreading only after 1470, but the tradition supported by the Dominicans was the origin of these images of Dominic, accompanied sometimes by other male or female saints (Catherine of Siena or Rose of Lima) of the Dominican order.

Ludovico Carracci,
*Madonna and Child with
Saint Dominic*, 1585–87,
Pinacoteca Nazionale, Bologna.

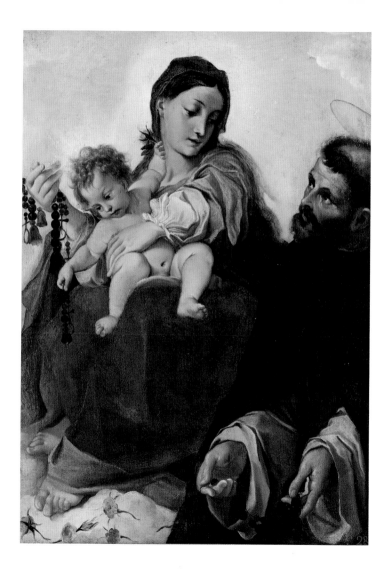

Lawrence

Feast day: August 10

Appearance: wears a deacon's vestments with a dalmatic or a stole worn crosswise

Attributes: gridiron, palm branch, book, alms box

Can be confused with: Saint Vincent of Saragossa

The unmistakable attribute of Saint Lawrence, deacon and martyr, is based on the legend of his martyrdom, according to which he was tortured by being roasted alive on a gridiron. When he is not depicted during this act of torture, his image is always that of a young deacon, most often dressed in a rich dalmatic, in some cases with a tunicle or a stole worn crosswise. Among his attributes are items of charity, sometimes represented by sacred articles made of gold, in reference to his decision to distribute the treasures of the church to the poor. It is said that when the city prefect demanded that he hand over the church's valuables, Lawrence responded that the church's jewels were the needy, thus earning the ire of Decius, and consequently arrest, torture, and martyrdom.

Biographical notes

A deacon, perhaps Spanish, he was called to Rome, where his pastoral and charitable acts were opposed by Emperor Decius. Arrested and tortured, he died a martyr in 258.

Patronage

Invoked against fires and lumbago; protector of rotisserie operators, restaurant owners, cooks, librarians, booksellers, pastry chefs, firemen, and glaziers

Bartolomeo della Gatta, *Saint Lawrence*, 1467, Arezzo cathedral.

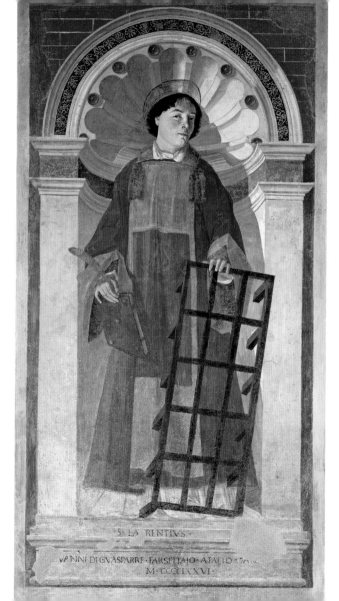

· S · LA RENTIVS ·

VANNI · DI · GVASPARRE · FARSETTAIO · AFATTO · FARE ·
M · CCCCLXXVI ·

Lawrence

Apocryphal tradition attributes to Saint Lawrence the torture of being roasted on a gridiron over live coals or, in other instances, flames. Each period in the history of art has produced depictions of the scene, with the emperor usually on hand to witness the torture while Saint Lawrence exhibits extraordinary calm. In creating such scenes, the artist is called on to show the resoluteness of the martyr in overcoming death while at the same time depicting the tradition of the words the saint spoke. According to *The Golden Legend* he called out to the emperor, "I'm done on this side. Turn me over, then you can eat!"

Palma Giovane, *Martyrdom of Saint Lawrence*, 1581–82, church of San Giacomo dall'Orto, Venice.

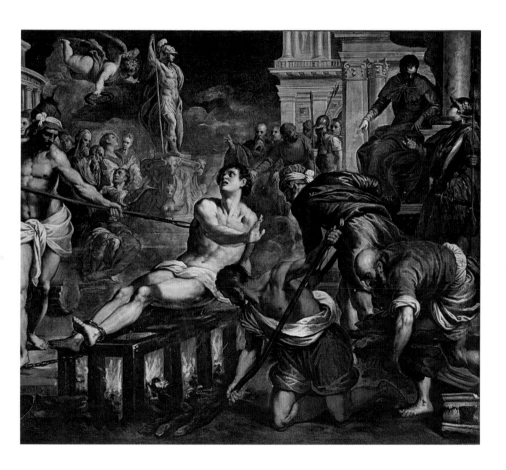

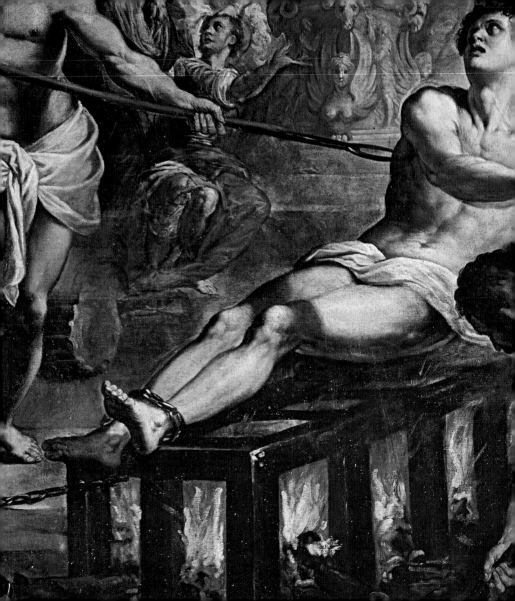

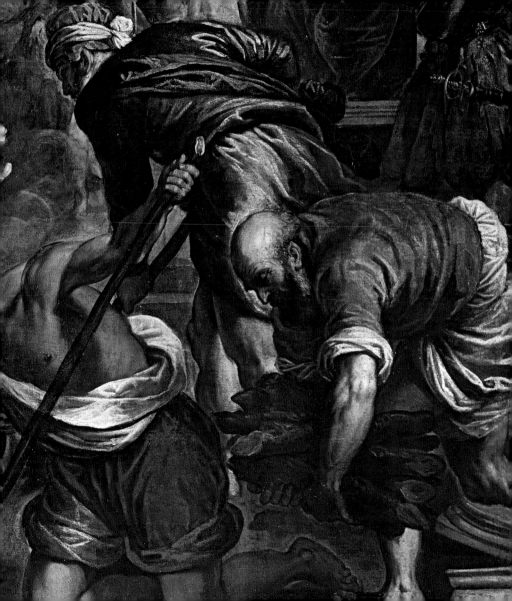

Clare of Assisi

Feast day: August 11

Identifying situation: displaying a monstrance

Appearance: wears the black or brown habit of her order

Attributes: monstrance, lamp, lily, cross, staff of an abbess, palm branch, book

In the oldest images of Clare of Assisi, she is depicted in a monk's habit held tight at the waist by a cord and holds a cross in her hand. She is shown holding a cross in the Lower Basilica of the Basilica of Saint Francis at Assisi in a fresco by Simone Martini circa 1318, although the same artist, only one year earlier, had painted her holding instead a branch of flowering lily. With the passage of time, as the habit of the Poor Clares became more clearly defined and as the legend of how she drove away Saracens attacking the city (she presented herself on the walls and held up a monstrance) took hold, her specific attribute became the monstrance, a receptacle in which the consecrated host is exposed for adoration. The palm branch that sometimes appears with the figure of Saint Clare is not a symbol of martyrdom but a reference to the day that she abandoned her family, which was Palm Sunday.

Biographical notes

Clare was born of a noble family in Assisi, Italy, in 1194. With the assistance of Francis of Assisi, she was able to follow his example and found a female order, the poor nuns of San Damiano, later called the Poor Clares, to which she gave the rule. She died in 1253.

Patronage

Protector of embroiderers, launderers, gilders, ironers, the blind, television, and telecommunications

Altichiero da Zevio, tondo with *Saint Clare*, 1372–79, parish church of Santi Pietro e Paolo, Mussolente (Vicenza).

Clare of Assisi

In the earliest images of Saint Clare, she often appears with a very particular attribute, an oil lamp or lantern. Apparently, when the flowering lily (symbol of virginity and purity) and the cross (emblematic of her consecration to Jesus Christ) no longer seemed adequate for her identification, a lamp or lantern was chosen, probably as a play on her name, following a somewhat recurrent method in the evolution of symbols. The name *Clare*, meaning "clear" or "luminous," could be understood as an obvious allusion to light and could be embodied by means of a small lamp. The lamp was later replaced by a monstrance, a more explicit attribute for the saint.

Bernardino Lanino, *Saint Clare*, c. 1530–83, Accademia Albertina delle Belle Arti, Turin.

Hippolytus

Hagiographic history presents two saints named Hippolytus, one a priest who was martyred together with Pope Pontian (pope during the period of Alexander Severus); the other a soldier who, according to *The Golden Legend*, was the jailer of Saint Lawrence, was converted by him, and also became a martyr of the third century. However, while there are two different saints with this name, there is only one iconography. The image of this saint and his atrocious torture, according to the popular tradition reported in *The Golden Legend*, are a result of his name: *Hippolytus* is from the Greek and means "unleasher of horses." This etymology was the basis for an attribute to make the saint recognizable— after numerous tortures, Hippolytus was tied to horses and torn apart.

Biographical notes
The iconography of a priest and martyr of the third century is combined with that of another saint's, a legendary soldier and the jailer of Saint Lawrence.

Patronage
Protector of horses and jailers

Dieric Bouts I, *Martyrdom of Saint Hippolytus*, c. 1470, cathedral museum, Bruges.

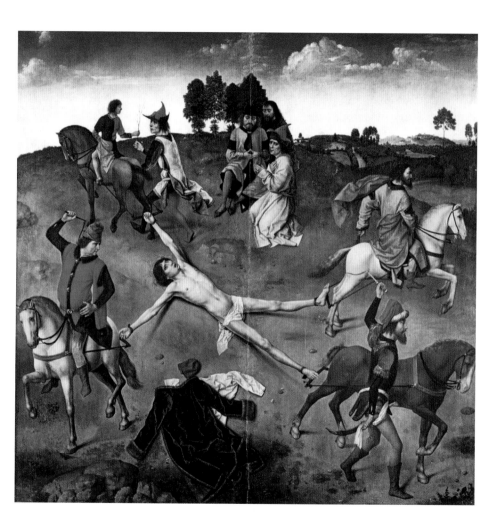

Roch

Feast day: August 16

Identifying situation: a man who reveals or leaves visible a sore indicating the plague

Appearance: usually dressed as a pilgrim

Attributes: dog with bread in its mouth, angel

Can be confused with: Saint James, an apostle dressed as a pilgrim, who never reveals a wound

The distinctive image of Saint Roch is that of a pilgrim with a sore that indicates he has the plague. The saint's dress is usually composed of a wide-brimmed hat and a cloak to which are attached one or more badges of the pilgrimages that he has taken (usually the seashell of Saint James, indicating the pilgrimage to Santiago de Compostela, but also frequent are the keys of Saint Peter with the tiara or the veronica, indicating the pilgrimage to Rome). The saint's other accoutrements are a pilgrim's staff, the canteen gourd, and a knapsack. The most important aspect of his depictions, however, is the way he reveals the sore on his thigh, proof he has caught the plague, which according to the legend he survived.

Biographical notes
Native of Montpellier, France, Roch (Rock) lived in the fourteenth century. A hermit, he went to Rome as a pilgrim and cared for plague victims there. He himself caught the plague but survived.

Patronage
Protector of pilgrims, travelers, pavers, invalids, prisoners, surgeons, pharmacists, and gravediggers

Cesare da Sesto, *Saint Roch*, 1523, Civici Musei d'Arte Antica, Castello Sforzesco, Milan.

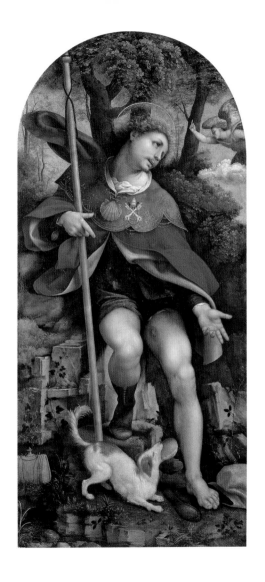

Roch

During his pilgrimage to Rome, Saint Roch gave loving care to many pilgrims suffering from the plague; on his way home he himself contracted the disease, with no one to turn to for assistance. He decided to wait for death in a forest, but instead of dying he was visited by an angel who helped him and revealed a spring where he could get water; he was further assisted by a small dog that brought him bread every day. On the basis of this legendary tale, the figure of the saint often appears together with a small dog holding bread in its mouth and by an angel, and these became his specific iconographic attributes.

Vincenzo Civerchio, *Saint Roch*, from the Saint Nicholas of Tolentino Polyptych, 1495, Pinacoteca Civica Tosio Martinengo, Brescia.

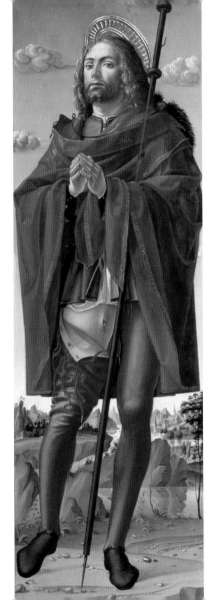

Helen

Feast day: August 18

Appearance: wears royal robes

Attributes: the cross of Jesus, nails from the cross, model of a church

All the attributes that together identify Saint Helen, mother of the emperor Constantine, refer to the finding of the true cross of Jesus and to the foundations in the Holy Land of the churches of the Nativity at Bethlehem and the Holy Sepulcher in Jerusalem. In the simplest images, Helen is depicted in the act of holding up a large wooden cross; she may wear regal clothing and may hold the nails of the cross, which according to tradition she gave to her son Constantine. Saint Helen is often shown accompanied by another attribute: the model of a holy building, an allusion to the foundations in the Holy Land of the first large basilicas, one at the place where Jesus was born and the other on the spot where he died.

Biographical notes
Mother of the emperor Constantine, Helen was born in Bithynia around 250. Around 312 she converted to Christianity. She made a pilgrimage to the Holy Land and found the true cross of Christ and had the churches of the Nativity and the Holy Sepulcher built. She died in 330.

Patronage
Invoked against storms and fire and by those in search of lost objects; protector of dyers and the makers of needles and nails

Lombard artist, *Saint Helen*, 13th century, basilica of San Lorenzo, Milan.

Louis of Anjou

Feast day: August 19

Appearance: youthful, wears a bishop's vestments over a Franciscan habit

Attributes: royal insignia, French lilies, a crown at his feet

Can be confused with: Saint Bonaventure, who wears a cardinal's vestments over a Franciscan habit but does not have a royal insignia

Regal origins, the decision to follow a religious life, and death at only twenty-three are the elements that define the earthly existence of Saint Louis of Anjou, the firstborn son of Charles of Anjou, and they have determined his image. Images of a man with a youthful appearance, combined with the bishop's attributes (cope, miter, and crosier), synthesize the story of Saint Louis in an unmistakable manner. More precisely, his cope is usually decorated with the lily of France, indicating the royal family to which he belonged, and a crown is often seen lying at the saint's feet in memory of the renounced throne.

Biographical notes
Born in 1274, Louis was the son of Charles of Anjou. Louis renounced the throne in favor of his brother, wishing to follow a religious life. As bishop of Toulouse, he dedicated himself to the assistance of the poor and needy. He died in 1297.

Patronage
Invoked against nervous breakdowns, lung disease, and tuberculosis

Piero della Francesca, *Saint Louis of Anjou*, 1460, Museo Civico, Sansepolcro (Arezzo).

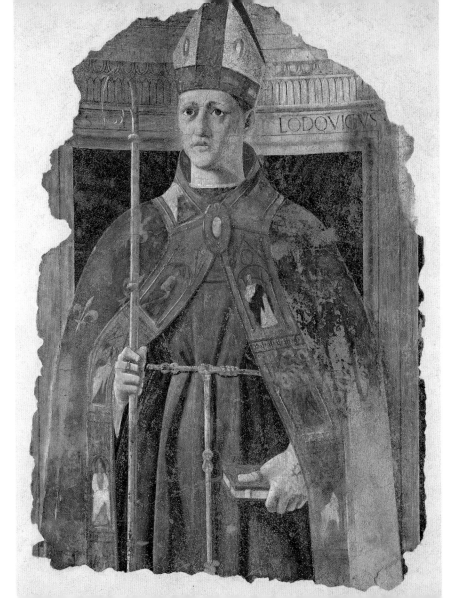

Bernard

Feast day: August 20

Appearance: wears the white Cistercian habit or the monastic scapular, with a tonsure

Attributes: abbot's pastoral staff, miter at his feet, host, chained demon, white dog, book as Doctor of the Church, beehive

Can be confused with: Saint Bernard of Aosta, who can also appear with a chained demon at his feet but wears a priest's cassock instead of a monk's habit

Images of Bernard usually present a figure dressed in the white Cistercian habit or in the monk's scapular (a long band of cloth with an opening for the head) holding an abbot's staff. Until around the fifteenth century, the saint's appearance was that of a monk with a long beard; later, with the change in the habits of monks, he was more often depicted shaven but always with a visible tonsure (shaven crown). The book of the rule and depiction as a Doctor of the Church are elements found in the iconography of other saints, as is the attribute of the chained demon being held underfoot, but a clear indication that the saint is Bernard is the presence of a beehive, for he was known as the "Mellifluous [honey-tongued] Doctor" because of his great eloquence. There is also a white dog that can show up in depictions of Bernard, in reference to a dream his mother had while she was carrying him in which she saw such a dog and understood "it was to be the warden of the house of God and would give great barkings against evil."

Biographical notes
Born near Dijon in 1090, Bernard founded the Cistercian order and died in 1153.

Patronage
Protector of beekeepers, candlemakers, and skiers

Pier Francesco Foschi, *Madonna Enthroned with Child and Saints Benedict and Bernard* (detail), c. 1540, church of San Barnaba, Florence.

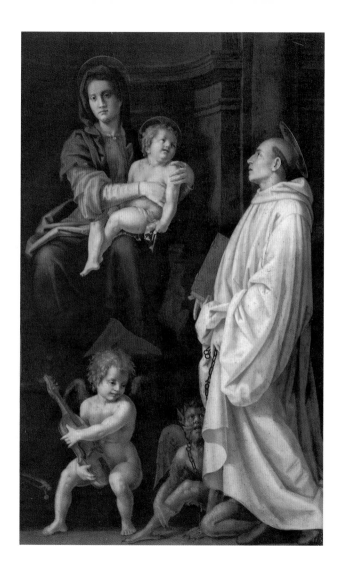

Bernard

Characteristic of the iconography of Saint Bernard are several depictions of the apparition of the Virgin or of Christ on the cross. Apparitions of the Virgin to Bernard are of two types: Mary presents herself to the saint while he is busy in his study and thus inspires his writings; or Mary appears in front of Bernard while he is in prayer and offers him milk from her breast (known as the Lactation Miracle). This second iconographic theme appeared around the thirteenth century and became especially popular between the sixteenth and the eighteenth. The images of the Lactation Miracle are a result of two different late legends concerning the saint's life, one in which Mary appeared in response to his recitation of the prayer *Mostra te esse matrem* ("Show yourself a mother") and another in which she appeared when he was still a young monk to offer him divine nutrition while he was preparing to preach in the presence of the bishop. Bernard's adoration of the crucified Christ is depicted in images that show him with the instruments of the Passion or that present him embracing Christ on the cross and drinking blood from the wound in Christ's side.

Alonso Cano, *The Miraculous Lactation of Saint Bernard*, 1658–60, Prado, Madrid.

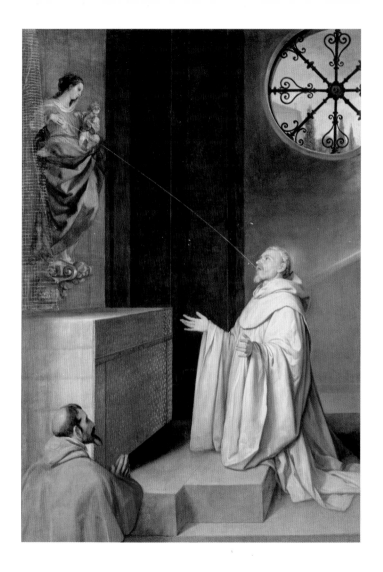

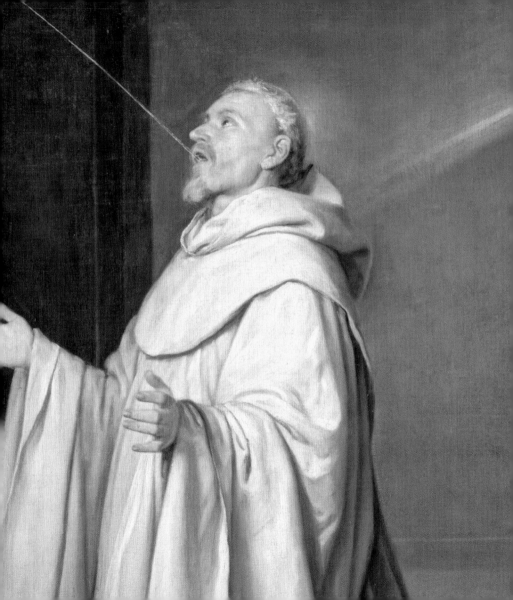

Rose of Lima

Feast day: August 23

Appearance: a young girl wearing the white habit and black mantle of the Dominican nuns

Attributes: roses, the Christ Child, crown of thorns

Can be confused with: Saint Rita and Saint Catherine of Siena (who wears similar clothes but has the stigmata)

The first person in the Americas to be canonized a saint, Rose lived between the end of the sixteenth and the beginning of the seventeenth centuries and led a life of prayer and mortification in keeping with the notion of spirituality of her time. The image of Rose matches the depictions of female mystics that recur in other saints of her period. Her primary attribute is roses, derived from her name: They are located near her or form a crown that she wears on her head, sometimes made only of thorns. Saint Rose is depicted in prayer holding a crucifix, with the Christ Child in her arms, or while receiving him from the Virgin.

Biographical notes

Born in Lima, Peru, in 1586, to parents of Spanish origin, she was called Isabelle Flores y del Oliva but was later known as Rose. She entered the Dominicans as a tertiary but kept her vows privately, living alone in a hut in the garden of her home in a state of destitution and mortification characterized by ecstatic experiences. She died in 1617.

Patronage

Invoked against fever, dropsy, and stomachache; protector of gardeners and Dominican nuns

Carlo Cignani, *Coronation of Saint Rose*, 17th century, Pinacoteca Civica, Forlì.

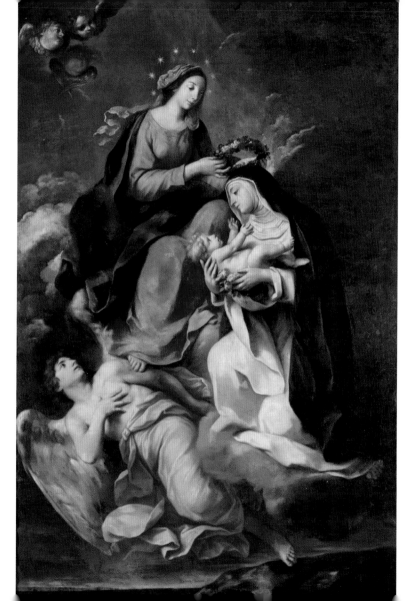

Bartholomew

Feast day: August 24

Identifying situation: a torture rack on which he is being flayed alive

Appearance: wears classical dress with a cloak

Attributes: knife; his own skin, which he holds in his hands; a book; in Spanish paintings he is shown with a chained demon

Unmistakable among the apostles, Bartholomew is depicted holding a butcher's knife because of the widespread belief, repeated and handed down in *The Golden Legend*, according to which before being martyred by crucifixion or decapitation (on the basis of another tradition), this apostle of Jesus was flayed alive. This torture is said to have occurred in Armenia, where Bartholomew went to preach after his visit to India. The saint's image, however, is often presented with the attribute of a book in reference to his figure as a disciple and preacher of the Word of God.

Biographical notes
An apostle of Jesus, Bartholomew lived around the first century.

Patronage
Protector of plasterers, tailors, furriers, binders, butchers, glovemakers, stewards, house painters, and tanners

Carlo Crivelli, *Saint Bartholomew*, late 15th century, Civici Musei d'Arte Antica, Castello Sforzesco, Milan.

Bartholomew

The image of the apostle dressed in a tunic and cloak with the book and the knife in his hands alternated with the image of a flayed man. Thus there has been the figure of the saint with or without the book in his hand, and the knife disappears as an attribute, leaving room for his own skin, which can be displayed or simply draped nonchalantly over the skinless body as though it were an article of clothing.

Marco d'Agrate, *Saint Bartholomew*, c. 1562, Milan cathedral.

Louis of France

Feast day: August 25

Appearance: wears royal robes

Attributes: lilies of France, scepter, globe, crown, crown of thorns, model of Sainte-Chapelle

The image of Saint Louis, king of France, presents all the attributes of a regal personage, usually adapted to the period of the artist rather than made to portray accurately the historical period in which he actually lived. Scepter, crown, and sometimes the globe and royal robes thus determine the saint's image, and he often also wears armor in memory of his participation in the Crusades. Never absent are references to the lily of France; if not on his clothing or mantle they appear as decorative elements on the scepter or crown. Another attribute, although not frequent, is the crown of thorns, the precious relic the king had brought to France from the Holy Land and for which he ordered construction of Sainte-Chapelle. The church itself sometimes appears in the saint's iconography as a model he holds in his hands.

Biographical notes

Born in 1214, he became King Louis IX at the age of twelve and governed France with great justice while leading a pious life, in many senses a model of sanctity. He died in 1270.

Patronage

Protector of carpenters, barbers, distillers, marble-workers, haberdashers, hairdressers, embroiderers, Franciscan tertiaries, the Military Order of Saint Louis, and the French Academy

Bartolomeo Vivarini, *Saint Louis of France*, detail of the Saint Ambrose Polyptych, 1477, Gallerie dell'Accademia, Venice.

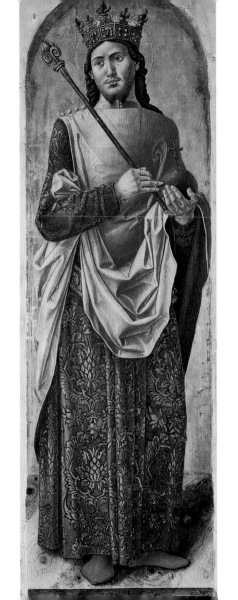

Alexander of Bergamo

Feast day: August 26

Appearance: dressed as a Roman soldier

Attributes: standard often decorated with the white lily of the Theban Legion, palm leaf

Can be confused with: Saint Maurice, a soldier in the same legion

Biographical notes
Alexander lived between the third and the fourth centuries. A Christian soldier and standard-bearer in the Theban Legion commanded by Saint Maurice, he escaped the massacre at Agaunum, taking refuge first in Milan, then in Como, and finally in Bergamo, where he was martyred in 303 after having preached and brought about many conversions.

Patronage
Protector of the city of Bergamo

Alexander, standard-bearer of the Theban Legion, was originally stationed in the East but later transferred to the West at Agaunum (modern-day Saint-Maurice-en-Valais). He is one of the numerous Roman soldiers who converted to Christianity (others being Martin, Maurice, and Sebastian) and earned martyrdom for refusing to carry out orders to persecute Christians or for refusing to renounce their faith and sacrifice to the gods. The primary events in Alexander of Bergamo's life are his refusal to carry out the command to persecute Christians, his consequent flight first to Milan then to Como and Bergamo, and his preaching, which led to his decapitation. His iconography is principally related to his being a solider, and he is therefore most often shown in armor with the standard, which may be decorated with the lily of the Theban Legion.

Varese or Ticino painter, *Saint Alexander*, early 16th century, Museo Bagatti Valsecchi, Milan.

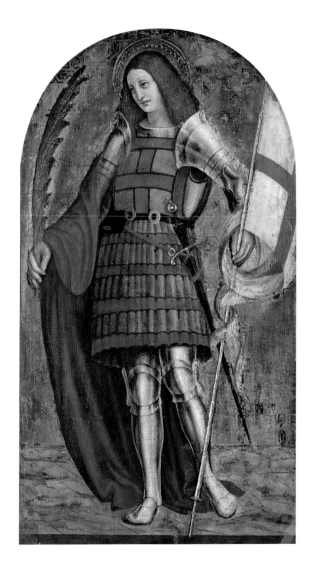

Monica

Feast day: August 27

Appearance: elderly woman, wears the black habit of the Augustinian nuns

Attributes: book of the rule, crucifix

Saint Monica's cult spread beginning in the tenth century but intensified in 1430 when her relics were moved from Ostia to the church of Saint Augustine in Rome. She is most often depicted together with other Augustinian saints (Augustine, Nicholas of Tolentino) or in episodes of the life of Saint Augustine. In such images (the most recurrent of her depictions) she wears the habit of an Augustinian nun, black with a white wimple under the veil. However, in some cases, she wears the habit worn by widows, reflecting her actual role as a widow in her lifetime and as patron saint to widows. In addition, her other symbols include the crucifix in clear reference to her firm faith, and the book of the rule, thus presenting Saint Monica as a nun following the rule of Saint Augustine.

Biographical notes
Monica was born in 332. She was the mother of Saint Augustine, caring for him lovingly before and after his conversion and becoming a model of the Christian mother. She died at Ostia in 387.

Patronage
Invoked as propitiatory of birth; protector of mothers and widows

Alvise Vivarini, *Saint Monica*, 1485–90, Gallerie dell'Accademia, Venice.

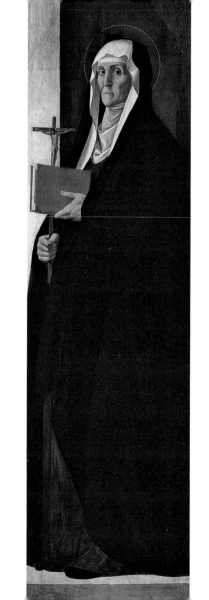

Augustine

Feast day: August 28

Appearance: wears bishop's vestments, sometimes the black habit of an Augustinian monk; usually has a beard and tonsure

Attributes: the dove symbolic of the Holy Spirit may appear near his ear, emblematic of the divine inspiration behind his writings; a pierced heart, flaming or bleeding; a vision of the Trinity; a child with a shell

Biographical notes

Born in 354 in Tagaste (Algeria) to a pagan father and Christian mother (Saint Monica), he renounced the Christian faith and studied history and philosophy. He taught grammar, rhetoric, and philosophy at Tagaste, Carthage, Rome, and Milan. Hearing the preaching of Bishop Ambrose he converted and was baptized in 386. He returned to Africa in 388, lived in a religious community, and in 391 was ordained priest. He became bishop of Hippo in 396 and died in 430.

Patronage

Protector of printers and theologians

When depicted on his own, Saint Augustine is usually presented as a bishop with cope, miter, and crosier and with a book in his hand. He is often located in a setting that alludes to study and may be accompanied by the other three Doctors of the Western Church (Ambrose, Jerome, Gregory). He is shown as an older man, and his North African origins are almost always overlooked (a very rare exception is the sixth-century image of the saint in Rome's Lateran Palace). As part of a cycle, as opposed to an isolated image, he is sometimes shown in the black hooded habit adopted by Augustinian monks, the fraternity that he founded on his return to Africa. The heart that is inflamed or pierced and bloody first appeared as his attribute around the fifteenth century and has been steadily recurrent since the seventeenth.

Piero della Francesca, *Saint Augustine*, 1454–69, Museu Nacional de Arte Antiga, Lisbon.

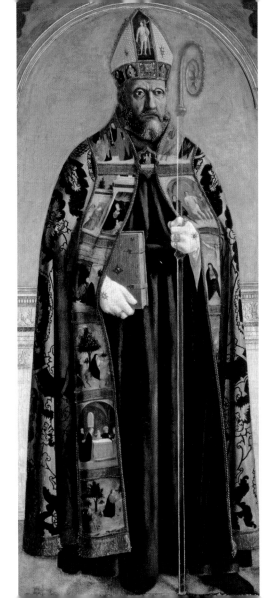

Augustine

Several episodes from Saint Augustine's life recur with a certain frequency over the span of art history. Among these are, in particular, his baptism by Saint Ambrose; his vision of the Holy Spirit while busy in his study; and the assistance he gave Jesus when he appeared to him dressed as a pilgrim and the saint washed his feet. Two very particular stories that involve Saint Augustine date to around the end of the fifteenth century. One is the saint's vision of the Trinity; the other is the story of his encounter with a small boy trying to empty the sea using a seashell. According to a medieval legend, Augustine encountered this child while walking along the seashore contemplating and trying to understand the mystery of the Trinity. When the child explained what he was trying to do, transferring the water of the sea to a hole using the shell, the saint told him it was impossible. The child responded, "No more impossible than what you are trying to do—comprehend the immensity of the Holy Trinity with your small intelligence."

Filippo Lippi, *Vision of Saint Augustine*, 1450–60, Hermitage, St. Petersburg.

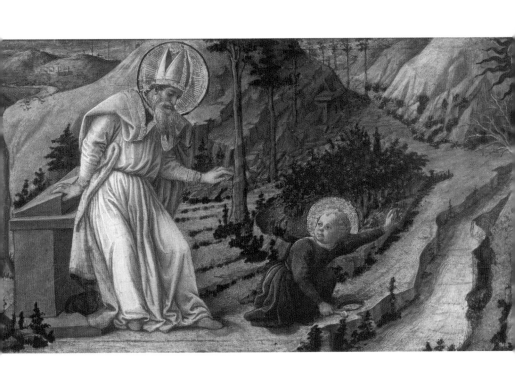

Giles

Feast day: September 1

Appearance: wears the black habit of the Benedictines

Attributes: deer, arrow

There is probably a relationship between the legend of Saint Giles and his name, of Greek origin, which means "kid." The best known episode of the hagiographic legend of this hermit saint (who became an abbot) is that of a deer (some versions make it a roebuck) chased during a hunt by King Wamba of the Goths; the animal sought refuge in the cave where Giles lived, offering its milk in exchange for protection, and the hermit did what he could to keep anyone from entering and harming the deer. But the arrow of another hunter wounded Giles while he protected the animal. The saint did not accept the king's offer of assistance but eventually agreed to become abbot of a monastery the king had built for him.

Biographical notes
Born around 640 in Athens, he moved to Provence where he founded a monastery that was later named for him. He died around 710.

Patronage
Invoked against fear; protector of the lame, lepers, and wet nurses

Portal with statue of Saint Giles, c. 1500, church of Saint-Giles, Abbeville.

Giles

Saint Giles's renown even in life combined with the belief in his powers of intercession are behind an episode that has become part of the saint's legend and that has also had an influence on his iconography. According to the story, Charles, king of the Franks, had committed a sin so grave that he could not bring himself to confess it, and so he asked the saint to intercede for him. During a Mass that Saint Giles celebrated for the king, an angel appeared and placed a piece of paper on the altar on which was written the king's sin along with his pardon, provided he repented.

Master of Saint Giles, *The Mass of Saint Giles*, 1480–90, National Gallery, London.

Gregory the Great

Feast day: September 3

Appearance: mature man wearing papal robes

Attributes: papal tiara, dove of the Holy Spirit, book

Pope and Doctor of the Western Church, Saint Gregory the Great can be identified first of all by his papal robes, most often elegant liturgical vestments (chasuble and cope), and the papal tiara (called in Latin the *triregnum*, it is a three-tiered crown and has been in use since the fourteenth century), which he may wear or have near him. His more personal iconographic attributes, the book and the dove of the Holy Spirit, refer to his position as a Doctor of the Church and to his figure as a scholar and lawmaker, as well as to his numerous written works of a pastoral character recognized as having been divinely inspired.

Biographical notes
Born around 540, Gregory became a monk and dedicated himself to the poor. Elected pope in 590, he was active in works of charity and missions. He contributed to the Roman liturgy and church music (Gregorian chant) and wrote important works of a pastoral, moral, and spiritual character. He died in 604.

Patronage
Invoked against the plague and gout; protector of musicians; singers; makers of ribbon, braid, and buttons; teachers; and popes

Carlo Saraceni (attr.), *Pope Gregory the Great*, 1615, Galleria Nazionale d'Arte Antica, Palazzo Barberini, Rome.

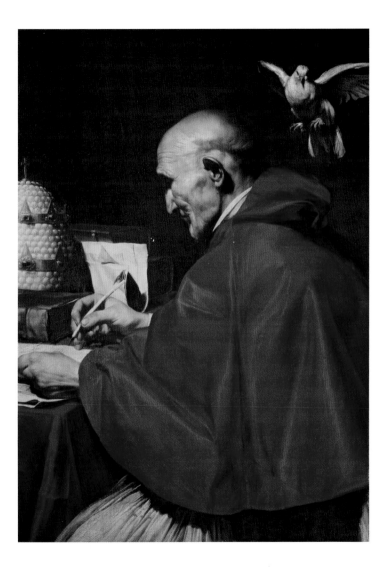

Gregory the Great

Saint Gregory the Great is often depicted while celebrating Mass in two different situations: when at the moment of the consecration he receives the apparition of the risen Christ (a type known as the Mass of Saint Gregory), who pours blood from his side to fill the chalice or in some other way proves the reality of transubstantiation; and when he prays for the souls in Purgatory. This latter image is derived in part from the prayer that Gregory wrote for the soul of the emperor Trajan (who had died five centuries earlier and whose upright life the saint admired)—Gregory later learned from an angelic voice that his prayer had been fulfilled—and in part from the contribution he made with his writings for the promotion of prayer for the souls in Purgatory. This image was destined to enjoy great success, beginning in the late sixteenth century.

Simone Brentana, *Saint Gregory and the Souls in Purgatory,* 1719, church of San Nicolò all'Arena, Verona.

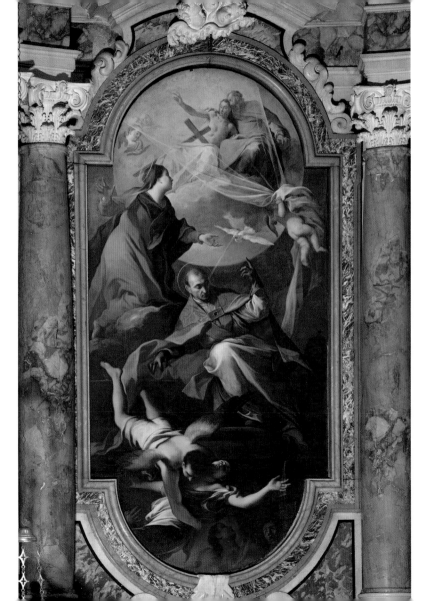

Rosalia

Feast day: September 4

Appearance: young woman wearing the simple clothing of a hermit

Attributes: rose, crucifix, skull, staff, scourge

Can be confused with: Saint Rose of Lima, Saint Rose of Viterbo, both of them associated with roses, but the former wears the Dominican habit, the latter the Franciscan

The cult of Saint Rosalia came into being almost immediately after her death in the thirteenth century, but the legendary stories about her earthly existence began spreading only after the discovery of her relics, which took place in 1624. The iconography of the saint is thus late and developed only over the course of the seventeenth century, on the basis of the stories that became related to her. The image that came into being was that of a young hermit who lived in prayer near a cave. Her attributes were those typical of hermits and penitents, from the skull to the crucifix, from the staff to the scourge. Another common symbol, related to her name, is a rose.

Biographical notes
Rosalia lived in the twelfth century. According to legend, she was a girl of noble birth who chose the life of a hermit and lived in a cave on Mount Pellegrino near Palermo.

Patronage
Invoked against the plague

Circle of Francesco Albani,
Saint Rosalia in Her Cave,
17th century, Quadreria
dell'Arcivescovado, Milan.

EGO ROSALIA
SINIBALDI QVISQVI
NELLAROSARVM
DOMINI FILIA AMOR
DNI MEI IESV
CHRISTI
ANIMO MEO
DEGREVI

Nicholas of Tolentino

Appearance: young man in the black habit of the Augustinian friars

Attributes: star in the middle of his chest, book of the rule, crucifix, flowering lily

The black habit with hood held in at the waist by a leather belt, usually also black, is the chosen dress of the Augustinian friars, the order to which Saint Nicholas belonged. His most unique attribute is a radiant star on his chest, which alludes to the episode in which Saint Nicholas was led by a luminous star when he went to the church at night. His other attributes include a crucifix and, sometimes, a flowering lily. Nicholas may also hold the book of the rule. In rare cases, his attributes may include souls amid the flames of Purgatory, in memory of the Mass he celebrated for the salvation of the souls in Purgatory following an apparition.

Biographical notes

He was born in 1245 in the March of Ancona, Italy. As an Augustinian friar he educated and cared for outcasts and the sick. At Tolentino (near his birthplace), he mediated in the conflict between the Guelphs and the Ghibellines. He died in 1305.

Patronage

Invoked against the plague and fevers and for the liberation of souls in Purgatory; protector of ecumenism, maternity, infancy, and souls in Purgatory

Benedetto Bembo, *Saint Nicholas of Tolentino*, 15th century, Museo Civico Ala Ponzone, Cremona.

Cornelius

Feast day: September 16

Appearance: wears papal robes

Attributes: hunting horn, papal tiara

The actual life of Saint Cornelius, third-century pope and martyr, has had nothing to do with his image in art or with the specific attribute linked with him. Saint Cornelius is most often depicted with a hunting horn, chosen for him because of his name, which is also why he is the patron saint of bovines, which are horned animals. In general, following the linear chronology of art history, Saint Cornelius has been outfitted with the clothing and attributes of a pope—elegant vestments, the three-tiered tiara, papal headdresses—according to the period of the artist making the depiction. Sometimes he is shown accompanied by Cyprian, bishop of Carthage, who defended him and supported his legitimacy during a difficult pontificate that included internal church problems, such as the admission of those who had abjured their faith during persecutions.

Biographical notes
Pope from 251 to 253, he died a martyr during the persecutions under Emperor Gallus.

Patronage
Protector of bovines

Anton Woensam, *Pope Cornelius*, early 16th century, Pushkin Museum, Moscow.

Januarius

Feast day: September 19

Identifying situation:
interceding to stop the eruption of Mount Vesuvius

Appearance: wears a bishop's vestments

Attributes: vials, palm branch, lions

The image of a bishop martyr with all the usual attributes (miter, crosier, book, palm branch) is unquestionably intended to represent Saint Januarius (Gennaro) when a specific item is included—a pair of vials. Almost always found in pictures of this saint, this attribute is based on the reliquary that contains his blood, which was collected in the two vials by a pious Christian woman following the saint's decapitation at Pozzuoli. This happened during the persecution of Christians under Emperor Diocletian. Before being beheaded, Januarius had been taken to the amphitheater to be eaten by lions, but the lions miraculously refused to harm him, which is why lions are listed among this saint's possible attributes. After the failure with the lions, he was thrown into a flaming furnace but walked out unharmed. This survival of flames suggested immunity to fire and thus also to lava, and Januarius also appears, although with less frequency, while praying to stop an eruption of Mount Vesuvius.

Biographical notes
Januarius was born around the end of the third century in Naples or Benevento. He was bishop and died during the persecutions of 305. His cult has existed since the fifth century.

Patronage
Invoked against the eruptions of Mount Vesuvius; protector of blood donors and goldsmiths

Francesco Solimena, *Saint Januarius*, 1701, chapel of the Treasury of Saint Januarius, Naples cathedral.

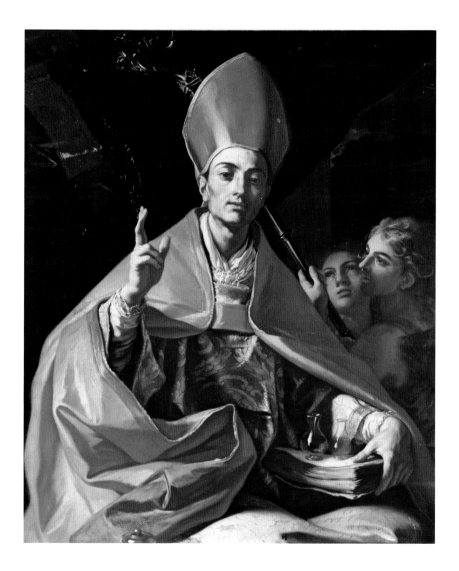

Eustace

Feast day: September 20

Identifying situation: a horseman or hunter encountering a stag with a crucifix between its antlers

Appearance: dressed as a knight, nobleman, or hunter

Attributes: stag with crucifix between its horns, crucifix, bronze bull (rare)

Can be confused with: Saint Hubert

Of all the events in the life of Placidus, the Roman soldier who changed his name to Eustace when he was baptized, it was the episode of the miraculous circumstance of his conversion that fed medieval legends and became the principal motif in his depictions. In fact, he converted while out hunting, following an encounter with a stag in the middle of a dense forest. There was a luminous crucifix between the stag's horns, and it spoke to the hunter, saying, "I am Jesus who you honor without knowing it." In rare cases Eustace has the attribute of a bronze bull in reference to the instrument of his martyrdom.

Biographical notes
A Roman soldier, he lived between the first and second centuries. He converted under miraculous circumstances while hunting, leading to the conversion of his family. After many trials he died a martyr, according to legend roasted to death inside of a bronze bull.

Patronage
Invoked against fire; protector of forest rangers, hunters, and those in difficult situations

Albrecht Dürer, *Vision of Saint Eustace*, 1501, Gabinetto Disegni e Stampe, Uffizi, Florence.

Matthew

Feast day: September 21

Identifying situation: a man seated at a table (in a customs house) being called by Jesus to follow him

Appearance: mature man in classical dress, most often writing

Attributes: book, angel, halberd

Saint Matthew (also called Levi in the Gospels of Mark and Luke) was a Jew disliked by the population since he worked for the Romans as a tax collector. He probably wrote his Gospel in Syria where he went to evangelize during the second half of the first century. His Gospel begins with the genealogy of Jesus; for this reason, the Fathers of the Church, choosing an image from among the Four Living Creatures described in both the book of Ezekiel and Revelation, attributed to him that of the winged man, later interpreted as the image of an angel. An angel is thus usually depicted near Matthew as an inspiration for his writings.

Biographical notes

Matthew lived in the first century and was an apostle and evangelist. He was called by Jesus while working as a tax collector. According to apocryphal sources, he died a martyr in Ethiopia.

Patronage

Protector of tax collectors, accountants, bookkeepers, clerks, and bankers

Girolamo Forabosco,
Saint Matthew and the Angel,
17th century, Pinacoteca
Nazionale, Ferrara.

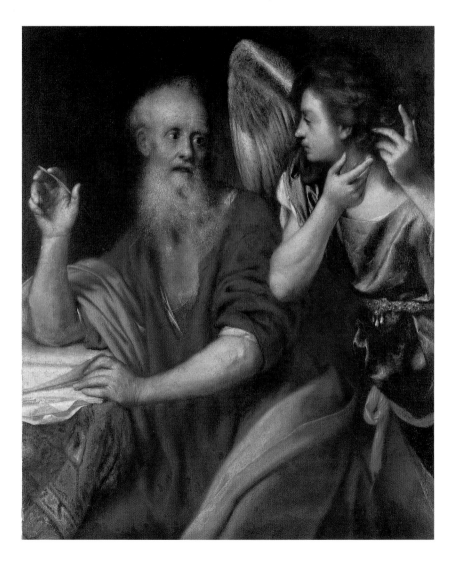

Matthew

The calling of Matthew is one of the most frequent depictions of this evangelist saint. Such images do not include the attributes of the Gospel and the angel, nor is the halberd, the axe-like instrument of Matthew's martyrdom, present. At least since the beginning of the modern age, Matthew's story is usually presented by distinct images that seem to contrast and then later blend: the career of tax collector and the invitation to another life from Jesus, which is freely accepted by the saint.

Hendrick Terbrugghen, *The Calling of Saint Matthew*, 1621, Centraal Museum, Utrecht.

Maurice

Feast day: September 22

Identifying situation: located amid numerous soldiers who submit to decapitation

Appearance: dressed as a soldier, sometimes with black skin

Attributes: standard, sword, palm branch

Can be confused with: Saint Alexander

The attributes of Saint Maurice are those of the soldier martyr saint: armor; standard (often decorated with a cross to indicate his role as commander); sword as instrument of martyrdom by decapitation; and palm branch, the award of the martyr. In some rare cases the saint is presented with black skin both because of his name (which means, "from Mauritania") and because he was part of the Theban Legion. Maurice is only rarely shown on horseback. The only unquestionable element for his recognition is the presence near or around him—or, on occasion, in the background of the scene—of numerous other soldiers being martyred, in memory of the six thousand members of his legion, who along with him gave their lives so as not to sacrifice to the idols.

Biographical notes

Maurice lived in the third century and was commander of the Theban Legion. He was martyred during the persecutions under Diocletian with his six thousand soldiers for refusing to sacrifice to the gods near Agaunum (today's Saint-Maurice-en-Valais).

Patronage

Invoked by sufferers of gout; protector of soldiers, mountain climbers, dyers, and Swiss Guards

Francesco Monti, *Madonna and Saint Maurice*, 1738–46, church of Santa Maria della Pace, Brescia.

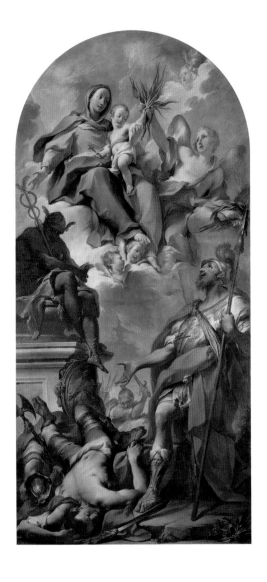

Cosmas and Damian

The brothers Cosmas and Damian, twins according to a late tradition, were Christian doctors who gave their services without payment. For this reason the principal elements of their identification are doctor's instruments (which vary according to the period in which the depiction was made), combined with the constant presence of the two saints together, impossible to distinguish from each other without descriptive captions. They may bear the palm branches of their martyrdom, having been beheaded under the emperor Diocletian. The information presented in *The Golden Legend* served as the source for several cycles that narrate the extraordinary deeds of the two saints.

Moretto da Brescia, *Saints Cosmas and Damian*, early 16th century, parish church, Marmentino (Brescia).

PANEM
ANGELORVM
MANDVCAVIT
HOMO

Gabriel

Feast day: September 29

Identifying situation: the angel of the Annunciation

Appearance: angelic

Attribute: branch of flowering lily

The archangel Gabriel is mentioned in both the Old and New Testaments, always as a messenger bearing the Word of God to men: Twice he is sent to the prophet Daniel; he brings Zacharias the announcement of the birth of John the Baptist; and he announces to the Virgin Mary the coming birth of Jesus, whose conception was the work of the Holy Spirit. This episode in the Gospel is the basis for the primary attribute of the archangel—the branch of flowering lily—which properly belongs to Mary as a symbol of purity and virginity but which has, in artistic representations, been transferred to the hand of Gabriel as a flower he bears in homage to the Virgin.

Notes
In the Bible he bears messages from God to humans.

Patronage
Protector of postal workers, radio operators, ambassadors, newsvendors, couriers, stamp collectors, radio-television communication, and workers in communications in general

Fra Angelico, *Annunciation* (detail), 1438–46, Museo di San Marco, Florence.

Trinitatis nobile triclinium

Michael

Feast day: September 29

Appearance: angelic figure, usually wearing armor

Attributes: dragon, sword, lance, scales

The depiction of the archangel Saint Michael is directly drawn from the book of Revelation, which cites him as the leader of the other angels in their victorious battle against the demon, represented as a terrible twelve-headed dragon. The iconographic attribute of the archangel warrior is thus a sword or lance with a defeated dragon at his feet. In some cases the combat itself is depicted against the being that incarnates the demon, which, according to the period of the work, can be a monstrous dragon or a body with semi-human features.

Notes
In Revelation he is indicated as the angel leading the celestial ranks.

Patronage
Invoked for a good death

Guido Reni, *Saint Michael Archangel*, 1635, church of Santa Maria della Concezione, Rome.

Michael

The book of Revelation was the origin for other writings on Saint Michael that together present him as a majestic figure able to weigh souls. This iconography has distant Egyptian origins (the weighing of the heart described in the *Book of the Dead*) that were later transferred to the West in the image of the archangel. The oldest depictions related to this iconographic theme were first inserted in scenes of the Last Judgment, but autonomous depictions of Saint Michael were later developed. In such images the archangel usually maintains his warrior attributes while weighing souls with a scale; in some cases he is shown battling with a demon that attempts to steal souls off the scale.

Pedro Espalargues the Younger, *Saint Michael Archangel Weighs the Souls*, 16th century, Pushkin Museum, Moscow.

Raphael

It is the archangel Raphael himself who, at the conclusion of the many adventures of his journey with Tobias, presents himself as "one of the seven holy angels which . . . go in and out before . . . the Holy one." He refuses any recompense for what he has accomplished. His image is therefore that of an angel who, to be recognized and distinguished from other angelic figures, is always accompanied by Tobias, sometimes depicted as a boy, sometimes as a young man, but always holding a large fish. This last attribute is merely a faithful representation of the biblical text: The fish is the large one that tries to eat the boy but that, with the help of Raphael, is captured, its liver and bile extracted and used to fight off a devil and heal Tobit's blindness. At times the elements used for recognition of Raphael and Tobias include a jar of medicine (in reference to the healings accomplished) and a small dog that, according to the biblical text, accompanied the travelers.

Notes

One of the seven angels near God. In the biblical book of Tobit (today included in the Apocrypha in the King James Version of the Old Testament), Raphael is the angel that accompanies and helps Tobias on his trip, healing his father, Tobit, of blindness.

Patronage

Protector of adolescents, the blind, and travelers

Titian (attr.), *The Archangel Raphael and Tobias*, 16th century, Gallerie dell'Accademia, Venice.

Jerome

Feast day: September 30

Appearance: wears the clothes of a cardinal or is half-naked

Attributes: lion, skull, book

Gesture: beats his chest with a stone while contemplating the crucifix

Can be confused with: Saint Onuphrius, who presents all the attributes of the penitent hermit, but not those of the cardinal

Biographical notes
Born in Dalmatia around 341, he studied in Rome, Aquileia, and Trier. In 366 he chose the religious life, becoming a monk and hermit. He wrote the Vulgate, the Latin translation of the Bible, and died in Bethlehem in 420.

Patronage
Invoked by those with failing eyesight; protector of the learned, students, archaeologists, booksellers, pilgrims, librarians, and translators

Saint Jerome was never a cardinal, but elements that allude to that ecclesiastical role appear constantly in his iconography. The explanation for this dates to the Middle Ages, when his image in art was being defined. No thought was given to the realities in the church during the first centuries of its existence, all thought going instead to the present church. It was thus taken for granted that if Saint Jerome had been a pope's secretary (Pope Damasus called him to Rome to create the Vulgate), he must have been a cardinal. From this assumption it was taken for granted that he was also a scholar, notions that over time took shape in the image of a humanist, often accompanied by a lion in reference to the last period of his life in the monastery in Bethlehem, when the saint relieved a lion suffering from a thorn in its paw.

Michael Pacher, *Saint Jerome*,
1483, Alte Pinakothek, Munich.

Jerome

Along with the image of the scholar, Jerome is also depicted as a penitent hermit, an image that had appeared by the fifteenth century, becoming increasingly widespread between the sixteenth and seventeenth. The saint is thus presented in the "desert," according to the contemporary European sense of where his hermitage had been located, meaning a rocky and desolate natural setting. In such images the saint appears half-naked with a long beard, and he contemplates a crucifix while striking his chest with a rock. He is accompanied by some of his usual attributes, such as the book (in reference to the Vulgate and his other written works), an hourglass and skull (*memento mori*, or reminder of mortality), and the lion. In these depictions there is always an element that recalls the saint's (presumed) status as cardinal: either the cardinal's hat or a cardinal-red cloak.

Ambrogio (da Fossano) Bergognone, *Saint Jerome*, 1510, Civici Musei d'Arte Antica, Castello Sforzesco, Milan.

Bavo of Ghent

Feast day: October 1

Appearance: depicted as a noble horseman or hunter

Attributes: falcon, hollow tree

Can be confused with: other hunter or horseman saints, such as Eustace

A falcon and the trappings of a noble horseman or hunter are the elements that make Bavo of Ghent recognizable, with clear reference to the life he renounced to become a monk. As related in the *Roman Martyrology*, Bavo left the secular life, distributed his goods among the poor, and lived in a monastery as a monk and disciple of Saint Amand. Even so, tradition recalls that he later chose to live as a hermit in the woods around Ghent. From this are derived several depictions of the saint near the hollow tree in which he lived.

Biographical notes
He was born in the Brabant into a noble family in 585. He abandoned the life of ease to serve the poor and then became a hermit. He died around 655.

Protector
Invoked against whooping cough and rheumatism

Geertgen tot Sint Jans, *Saint Bavo of Ghent*, late 15th century, Hermitage, St. Petersburg.

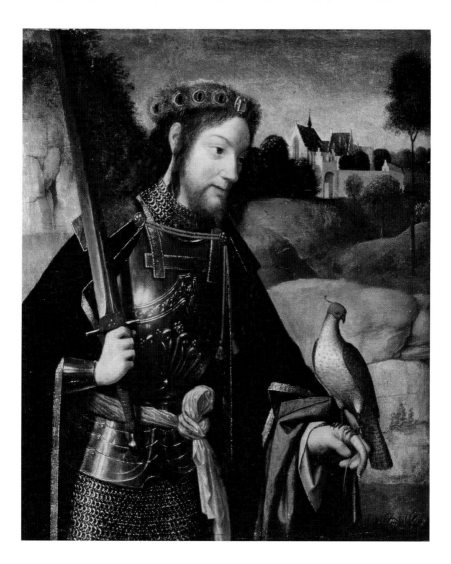

Francis of Assisi

Feast day: October 4

Identifying situation: receives the stigmata in the presence of a vision of an angel on a cross

Appearance: usually a young and delicate man wearing the brown Franciscan habit with a cord at the waist

Attributes: stigmata, cross, book

The first element for identifying Saint Francis of Assisi is the habit, to which have been added very few other attributes, such as the stigmata—the unmistakable wounds of Jesus in the hands, feet, and side—the cross, and the book. The characteristic by which the habit of Saint Francis can be unquestionably recognized is the cord tied at the waist like a belt, usually knotted three times along one of the two ends. The style is always similar but varies in part according to the period and the patron of the work, meaning according to how the Franciscan habit was worn at different times and by different families of the Franciscan order. The habit can have a sewn-on or detached hood or a hood worn on the head, can be of new fabric or patched, and appears in colors that vary from gray to various shades of brown.

Biographical notes

Born in Assisi in 1181, Francis renounced the dream of becoming a soldier to follow God in poverty. In 1208 he began preaching penitence, dressed in sackcloth, and lived from begging; he was soon joined by his first companions. He founded the order of Friars Minor; in 1224 he received the stigmata. He died on October 3, 1226.

Patronage

Protector of merchants, ropemakers, ecologists, florists, traders, upholsterers, and poets

Simone Martini, *Saint Francis of Assisi*, c. 1320, Lower Basilica, Basilica of Saint Francis, Assisi.

Francis
of Assisi

Since the very earliest depictions of Saint Francis of Assisi, he has been shown in the presence of a book, sometimes holding it with great care. At times this book, in the form of a codex, has the appearance of a precious object, an element that would thus clash with the extreme poverty of the habit and general appearance of the saint. The book is symbolic of the rule of the order that Saint Francis founded (and is a common element in the iconography of saints who founded religious orders); at the same time, it is a specific indication of the Gospels, the Word incarnate (the rule of Saint Francis was to follow the Gospel), and is thus symbolic of the disciples of Jesus. Along with the book there is also often a cross that the saint holds in his hands or uses as an object of prayer or contemplation, emphasizing its tie with Christ crucified, a relationship that, for Saint Francis, achieved its highest expression in his reception of the stigmata.

Caravaggio, *Saint Francis in Meditation*, 1606–07, Museo Civico Ala Ponzone, Cremona.

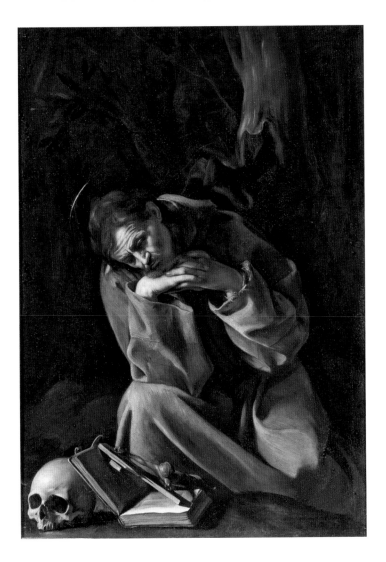

Bruno of Cologne

Feast day: October 6

Appearance: wears the white habit of the Carthusians

Attributes: shaft of the cross sprouting green leaves, seven stars, miter and crosier at his feet, skull

Gesture: sign of silence with the finger held in front of his mouth, arms crossed on chest

Saint Bruno, founder of the Carthusian order, is always depicted wearing the white habit with hood and large scapular (a long band of cloth with an opening for the head) adopted by the Carthusians. Because of the particular rule of the order, Bruno may be depicted with his arms crossed on his chest and with a finger held to his mouth in the sign of silence. Characteristic elements of images of the saint are the seven stars that, according to a vision of Saint Hugh (the bishop of Grenoble who gave Bruno the land for the foundation of his charterhouse), stood for Bruno and his first companions. Artworks also sometimes feature the shaft of the cross with three olive branches derived from a reading of the 52nd Psalm: "I am like an olive tree flourishing in the house of God." Saint Bruno is also depicted with a miter and crosier at his feet since he turned down the archbishopric of Reggio Calabria.

Biographical notes
Bruno was born in Cologne around 1032. First a canon, he became a monk and then founded the order of Carthusian monks at Chartreuse, inspired by Saint Benedict and Eastern monasticism. He died in Calabria in 1101.

Patronage
Invoked against the plague; protector of the Carthusian order

Daniele Seiter, *Saint Bruno*, 1700, Musée des Beaux Arts, Marseille.

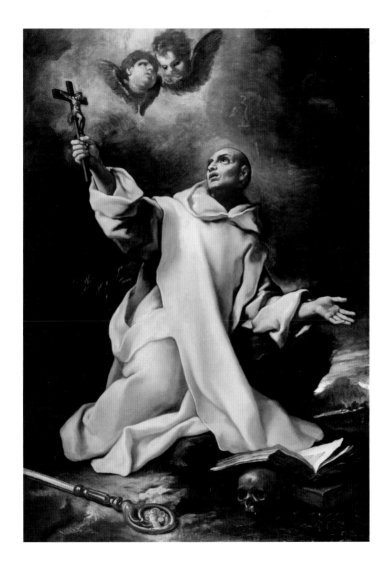

Justina of Padua

Feast day: October 7

Appearance: young woman with regal dress

Attributes: palm branch, crown of glory, knife stuck in chest, sometimes a book, dragon, unicorn

The iconographic attributes of Saint Justina of Padua have no direct relationship either to the episodes of her life or to the events of her martyrdom, having been borrowed from other female saints. All that is known of Justina with certainty is that she was baptized by the first bishop of Padua, Saint Prosdocimus, and that she was martyred during the persecutions under Emperor Maximian, probably in 304, perhaps by decapitation. Thus, as result of her martyrdom, her symbols include the palm branch and a crown of glory. However, she has two less obvious symbols: The unicorn is a result of confusion with the emblem of chastity of Saint Justina of Antioch, and the dagger stuck in her heart may be an iconographic adaptation of the sword with which she was beheaded.

Biographical notes
Justina lived in the third century and died a martyr, probably in 304, in Padua.

Patronage
Protector of the congregation of the Benedictines

Andrea Mantegna, *Saint Justina*, 1453–54, Pinacoteca di Brera, Milan.

Denis

Feast day: October 9

Identifying situation: being beheaded together with the deacon Rusticus and the priest Eleutherius

Appearance: wears bishop's vestments

Attribute: his head, which he holds in his hands

Saint Denis (Dionysius) is depicted in the liturgical vestments of a bishop, often bearing his own chopped-off head in his hands in memory of his martyrdom, which he suffered together with two companions, the deacon Rusticus and the priest Eleutherius, the three of them having together promoted the evangelization of Paris. *The Golden Legend* contains a good deal of information about Saint Denis, including the many tortures he and his companions suffered, but the event most often chosen for depiction is his martyrdom by decapitation or sometimes the miraculous event of the night that preceded this, when Denis, celebrating Mass in prison, was visited by Christ, who brought him the communion.

Biographical notes
Probably born in Italy, he was martyred during the third century, when he was beheaded in Paris around 250.

Patronage
Invoked against migraines

Peter Strüb (Messkirch Master), *Saint Denis, Bishop of Paris*, 1530, from the collegiate church of Sankt Martin, Staatsgalerie, Stuttgart.

SAT⁹ DIONYSIVS EPS E · M ·

Theresa of Avila

Feast day: October 15

Appearance: wears the brown habit with broad scapular (a long, wide band of cloth with an opening for the head) and white mantle of the Carmelites

Attributes: arrow in her chest, dove

The mystical events and frequent ecstatic visions experienced by Saint Theresa of Avila are the elements that have influenced her iconography, beginning in the period of the Counter-Reformation, which favored the spread of an image in which her passionate love for God could be "visually" recognized in the heart pierced by an arrow, often borne by an angel. The dove that is sometimes shown beside the saint, most often while she is writing, is symbolic of the divine inspiration of the Holy Spirit and emphasizes Theresa's role as a Doctor of the Church.

Biographical notes

Born in Avila in 1515, at twenty she entered the Carmelite convent of her native city where she had mystical experiences and ecstatic visions, documented in her writings. She reformed the Carmelite order and died in 1582.

Patronage

Invoked for the relief of souls in Purgatory and against heart diseases; protector of Carmelites

Sebastiano Ricci, *Ecstasy of Saint Theresa*, 1725, church of San Marco (formerly San Girolamo degli Scalzi), Venice.

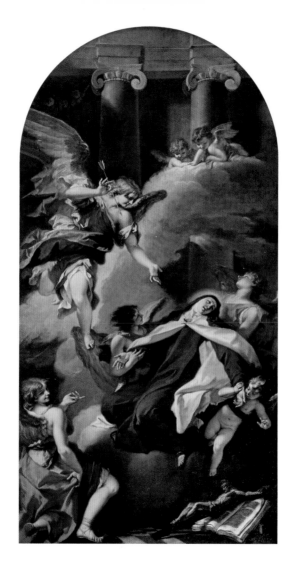

Ignatius of Antioch

Feast day: October 17

Appearance: wears a bishop's vestments often with the pallium with crosses according to the uses of the Greek Church

Attributes: lions, palm branch, bishop's crosier, wounded heart

Can be confused with: Saint Januarius, the prophet Daniel amid the lions

The iconographic theme of Ignatius, bishop of Antioch—being martyred in the Colosseum, attacked by lions—is somewhat rare in the West, and is more easily encountered in an Eastern setting, where the bishop's vestments display the characteristics of the Greek Church, with the pallium (the narrow band of wool worn across the shoulders) decorated with numerous crosses. Saint Ignatius was also called *Theophorus* ("God-bearer") because he bore God in his own heart: It is said that after his death his heart was removed from his chest, and it bore the monogram of Jesus, IHS (*Iesus Hominum Salvator*). This episode is the source of the attribute used in Western iconography of this saint: a wounded heart.

Biographical notes
Originally from Syria, he was the third bishop of Antioch. Arrested during the persecutions under Trajan he was condemned to be martyred in the Colosseum in Rome, where he died in 107.

Patronage
Formerly invoked against throat ailments, although over time these devotions have been lost

Lorenzo Lotto, *Madonna and Child with Saints Ignatius of Antioch and Onuphrius*, 1508, Galleria Borghese, Rome.

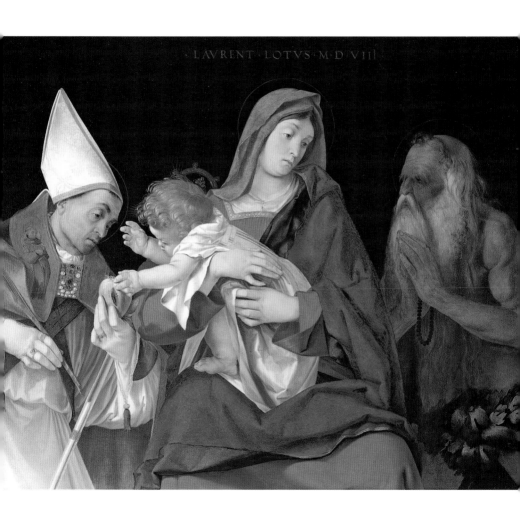

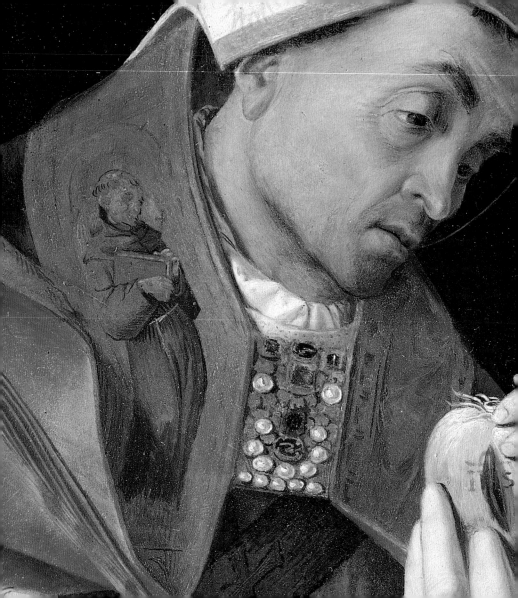

Luke the Evangelist

Feast day: October 18

Appearance: shown while writing his Gospel or painting a portrait of the Virgin

Attributes: book, winged ox

The book of the Gospels is the primary symbol of Saint Luke, followed closely by the winged ox. This animal was drawn from the Four Living Creatures presented in biblical visions (the books of Ezekiel and Revelation) that were associated with the evangelists in the works of the Fathers of the Church. The ox was put in relation to Luke since, at the beginning of his Gospel, he narrates the sacrifice of Zacharias, and a logical tie was seen between the immolation and the ox as an animal that was sacrificed. Luke's having been a doctor and the time he spent as a disciple of Saint Paul, accompanying him on some of his missionary journeys, have not had any influence on his presentation in art.

Biographical notes
Luke lived in the first century and wrote the third Gospel as well as the Acts of the Apostles. A Greek physician, he converted to Christianity, was part of the community of Antioch, and collaborated with Saint Paul.

Patronage
Protector of surgeons, gilders, glaziers, doctors, illuminators, notaries, writers, and artists

Saint Luke the Evangelist, from the *Lorsch Evangeliary*, 780–820, Biblioteca Apostolica Vaticana, Ms. Pal. Lat. 50, fol. 1 v., Vatican, Rome.

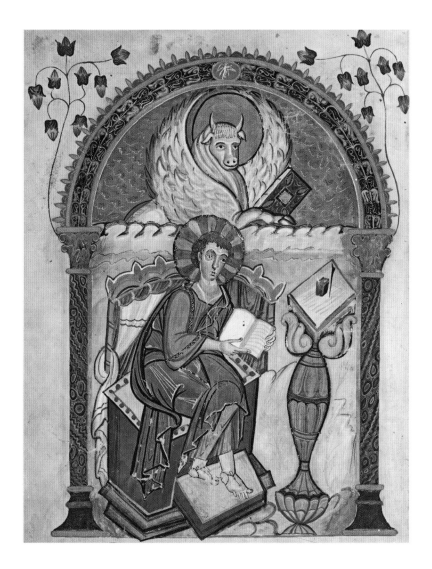

Luke the Evangelist

The Gospel written by Saint Luke contains so many details of the story of the infant Jesus that it might seem the evangelist had learned of the events directly from the Virgin Mary herself. Known for his skills as a sharp observer, (which emerge from another of his writings, the Acts of the Apostles) Luke, according to legend, was also a painter, and it was said that he made the first portrait of Mary. This popular belief led to the development of a special image of Saint Luke as a painter busy making a portrait of the Virgin and Child posing for him, a depiction that enjoyed special popularity among the Flemish artists of the fifteenth and sixteenth centuries.

Jan de Beer, *Saint Luke Paints the Virgin and Child*, 1535, Pinacoteca di Brera, Milan.

Ursula

Appearance: young princess with crown and large mantle

Attributes: banner with cross, arrow, palm branch, girls

Gesture: sheltering numerous girls under her mantle

The story of Saint Ursula was enriched by a legend in which her martyrdom came to include the deaths of eleven thousand companions. This amplification took place following the discovery of several tombs of young martyrs in the eighth century at Cologne, combined with the mistaken interpretation of an inscription near the name Ursula. The legend is based on a *passio* written in the tenth century that was also included in *The Golden Legend*. The young princess is often depicted with a crown and regal dress; as a martyr, her attributes include the palm branch and the banner with the cross, a sign of her triumph over death by means of martyrdom, a long arrow—the weapon that caused her death—and a crowd of girls protected under her wide cloak in memory of the legendary eleven thousand virgin companions who were martyred together with her.

Biographical notes
A Breton princess of the fourth century, sworn to God, she accepted marriage to a pagan prince on condition that he convert. She was killed by the Huns at Cologne while returning from a pilgrimage to Rome.

Patronage
Invoked for a happy marriage, a good death, and against burns; protector of girls and female students

Saint Ursula and Her Companions Under Her Mantle, 15th century, Memling Museum, Bruges.

Simon

Feast day: October 28

Appearance: wears tunic and pallium

Attributes: saw, book

Depictions of the Apostle Simon are not characterized by any specific, recurrent elements. It is even difficult to establish whether he is most often depicted young or old. He is often presented together with the apostle Thaddaeus (with whom he was martyred in Persia), and his image is often the general one of a disciple: He wears classical dress and may hold a book. There are no elements that might characterize him as a Zealot, but since the Middle Ages he has appeared accompanied by one special attribute—a saw, which is thought to have been the instrument of his martyrdom (he was sawn in half), although this attribution, without support in canonical texts, is based entirely on apocryphal sources.

Biographical notes
Simon lived in the first century and was one the twelve apostles of Jesus. According to the Bible he was a Canaanite member of the fanatical sect of the Zealots, who had formed a resistance movement against the Roman occupation of Palestine.

Patronage
Protector of cutters of wood and marble and fishermen

Federico Barocci, *Madonna with Saint Simon*, 1567, Galleria Nazionale delle Marche, Urbino.

Hubert

Feast day: November 3

Appearance: shown in bishop's vestments or as a hunter

Attributes: stag with crucifix between its antlers, hunting horn, falcon, hunting dogs

Can be confused with: Saint Eustace

Hubert's cult was already widespread by the ninth century, but it was later enlarged with the legend concerning the saint's conversion, which supposedly took place during a hunt following his encounter with a stag bearing a crucifix between its antlers. This legend is the source of the well-known image of Saint Hubert dressed as a hunter and kneeling before the stag; or he can be shown standing alone with the stag and in the dress of a bishop but bearing a hunter's attributes, such as a hunting horn and hunting dogs, or a falcon, thus combining the attributes of a bishop saint with those of a hunter.

Biographical notes

Born into a noble family around 655, Hubert became the bishop of Tongres-Maestricht in 705 and was later the first bishop of Liège. He dedicated his life to the evangelization of the Ardennes district of Belgium. He died in 727.

Patronage

Invoked against rabies and the bites of reptiles; protector of forest rangers, workers of hides, butchers, and hunting dogs

Jean Bourdichon, *Saint Hubert*, miniature from the *Book of Hours of Anne of Brittany*, 15th century, Bibliothèque Nationale de France, Paris.

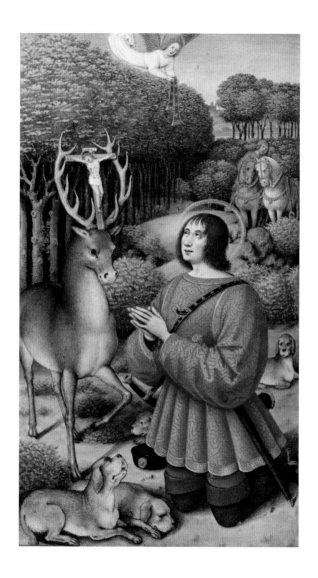

Charles Borromeo

Feast day: November 4

Identifying situation: visiting plague victims

Appearance: shown in the dress of a cardinal; rarely appears without the characteristic large, aquiline nose

Attributes: the motto *Humilitas*, sometimes a cord around his neck as sign of penitence, skull, book, pallium, miter, crosier

Biographical notes
Born in Arona, Italy, in 1538, into a family of the Lombard aristocracy, he was bishop and cardinal of Milan, during the Counter-Reformation. He carried out the reform dictates of the Council of Trent with important pastoral activity and works of charity, most especially during the serious plague of 1576. He died in 1584.

Patronage
Invoked against the plague; protector of catechists, the clergy, teachers, and starch-makers

The extraordinary diffusion of the image of Charles Borromeo is without doubt a result of the great devotion to him that came into being immediately after his death and that led to his canonization in 1610. The image of Saint Charles Borromeo (perhaps drawn from a sketch or drawing made of him in life) soon became codified in the figure of the cardinal in a red cardinal's cassock, a white tunic, or in the everyday clothes of a bishop saint; in the most widespread versions he is shown in the attitude of ecstatic prayer before the crucifix, with the attributes of the penitent saint, such as the skull and the book of the Gospels. After his canonization and most especially in the area of Milan, the image of the saint in glory became widespread. In this image preference is given to the figure of the bishop (holy successor to Ambrose) rather than that of a cardinal; in fact, the cardinal's insignia disappeared to make clear the symbols of the bishop—the pallium (narrow band of wool worn across the shoulders), miter, and crosier. In some cases his family motto, *Humilitas*, is included.

Morazzone, *Saint Charles in Glory*, 1611, church of Sant'Angelo, Milan.

Charles Borromeo

Saint Charles Borromeo became the saint of the terrible plague that struck Milan from 1576 to 1577, and his activities are remembered in a series of iconographic images that depict the bishop saint among the plague victims; while visiting them or administering the sacraments; while leading penitential processions through the city bearing the reliquary of the Holy Nail; and while advancing as a penitent himself dressed in sackcloth, his feet bare, and a cord around his neck. One particular iconographic motif shows the penitent bishop kneeling in prayer in front of the body of Jesus just taken down from the cross. This image makes reference to the long prayers the saint recited at the chapel of the deposition at the Sacred Mountain of Varallo and to a particular moment in which he had the sensation that he was praying near the true body of Jesus and not near a statue, and it was in that moment that an angel appeared to him and announced his own imminent death.

Giovanni Battista Crespi, *Dead Christ Adored by Saint Charles* (detail), early 17th century, Prado, Madrid.

Elizabeth

Feast day: November 5

Identifying situation: embraces the Virgin Mary during the Visitation

Appearance: elderly woman

Attribute: presence of the young Saint John the Baptist

Saint Elizabeth, wife of Zacharias, was a cousin of the Virgin Mary. The images of Elizabeth take inspiration from events described in the Bible. She is cited in the Bible in three circumstances: the conception and birth of Saint John the Baptist, whom she conceived even though she was old and thought to be sterile; the proclamation of the angel Gabriel when he makes the annunciation to the Virgin and tells her that her cousin Elizabeth, "who was called barren," is already in her sixth month; and the Visitation with Mary. The few other details that have been drawn from apocryphal sources tend to concentrate on the childhood and education of John the Baptist. Elizabeth is recognized for her appearance as an elderly woman accompanied by a baby or young boy who is John the Baptist.

Biographical notes
A relative, probably a cousin, of the Virgin Mary, Elizabeth was the mother of Saint John the Baptist. She conceived, even though she was old and thought to be barren, and in her sixth month was visited by her young cousin Mary.

Patronage
Protector of sterile women and those giving birth

Giulio Romano, *Madonna of the Cat*, 1523, Museo Nazionale di Capodimonte, Naples.

Elizabeth

Among the episodes from the life of Saint Elizabeth that have been depicted in the history of art, two are of special importance: the birth of John the Baptist and Elizabeth's meeting with Mary, known as the Visitation, when at the sound of their greetings John leapt for joy in Elizabeth's womb. Such images appear most often in cycles relating the life of Jesus and Mary or of Saint John the Baptist, and in each period of art history attention has been given to the special relationship between the two women, emphasizing the difference in age between Elizabeth and Mary, a difference that is manifested in both the definition of their physical appearances and in their dress. The two women, both pregnant (wearing beltless gowns or gowns with a very high waist), greet each other according to the customs in use during the period of the work of art, which range from a polite bow to an embrace, a kiss, or a handshake. In some cases, most of all in northern European art, the presence of the babies in the two wombs may be indicated.

Ambrogio (da Fossano) Bergognone, *The Visitation*, 15th century, Sanctuary of the Incoronata, Lodi.

Leonard of Noblac

Feast day: November 6

Appearance: wears the dress of a monk or hermit or that of a deacon

Attributes: shackles and chains, sometimes freed prisoners at his feet

Saint Leonard of Noblac was so concerned for the welfare of prisoners that, by way of the close relationship he enjoyed with the king, he obtained the release of many of them. His principal attributes are shackles and chains and, in some instances, the figures of freed prisoners. The prisoners are usually depicted kneeling at his feet, since those who had benefited from Leonard's intervention brought him their broken chains once freed. As for the saint's clothing, he usually wears that of a monk or hermit but may be presented in the dalmatic of a deacon even though there is no particular reference to that position in his hagiography.

Biographical notes

A Frankish noble of the sixth century, Leonard converted and was baptized by Saint Remigius, bishop of Rheims. He became a monk and was affiliated with the court of King Clovis I. The king gave him vast land for the foundation of a monastery. He died around 560.

Patronage

Invoked to ease the pains of childbirth and by sterile women; protector of farmers, blacksmiths, fruit vendors, and prisoners

Giovanni Battista Pittoni, *Madonna and Saints Leonard and Francis of Paola*, 1737, Museo Diocesano, Brescia.

Leo the Great

Feast day: November 10

Appearance: papal robes

Attributes: papal tiara, processional cross

Except in those images where he is shown meeting with Attila and his army of Huns and convincing them to turn away and not sack Rome, Saint Leo the Great is difficult to recognize for he has no specific attributes. He is depicted in pontifical robes: a richly decorated cope, tiara, and processional cross. In the meeting with Attila he is accompanied by the figures of Saint Peter and Saint Paul (who are present in the version of the story given in *The Golden Legend*), and they support the pope by drawing their swords against the king of the Huns.

Biographical notes

Elected pope in 441, he made contributions to theological and political matters. At the Council of Chalcedon (451) he stated the doctrine of the Incarnation of Christ. He is traditionally credited with meeting Attila the Hun and stopping his advance on Rome after sacking Milan (452). He died in 461.

Patronage

Protector of sacred music, musicians, and singers

Francisco de Herrera, *Saint Leo the Great*, 1660, Prado, Madrid.

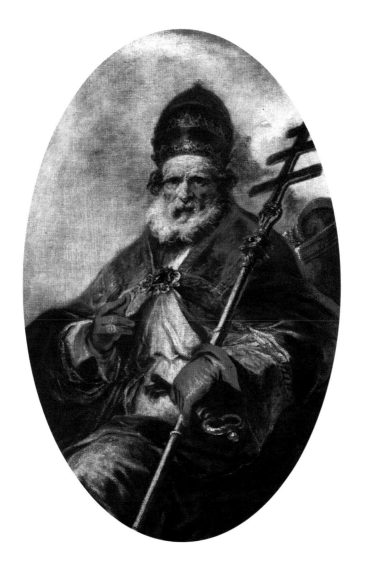

Martin of Tours

Feast day: November 11

Appearance: depicted as a soldier or bishop

Attributes: cloak that he cuts in half with a sword, beggar, miter, crosier

Saint Martin was acclaimed bishop by the people and clergy in 370 and directed the diocese of Tours for twenty-seven years, until his death. The insignia of a bishop, miter, and crosier are frequent attributes but rarely appear separated from elements that recall this saint's great generosity and charity. Numerous instances of charitable acts were related by Sulpicius Severus and by Gregory of Tours before being included in *The Golden Legend* of Jacobus de Voragine. These acts of charity became his principal attribute, particularly as related to the poor and needy, to whom Martin gave not only money (as in the image shown here, which is uncommon in his iconography) but also most of his clothing, depriving himself by doing so.

Biographical notes

Martin was born in Pannonia, Hungary, around 315. He had already become a soldier when he converted to Christianity; he asked to be released from service and was baptized. He was made bishop of Tours and died in 397.

Patronage

Protector of beggars, tailors, innkeepers, hoteliers, and soldiers

Simon Frank, *Saint Martin*, early 16th century, Museen der Stadt, Aschaffenburg.

Martin of Tours

The best-known episode from the life of Saint Martin of Tours is that of his donation of his cloak, which he cut in half with his sword, giving half to a poor man. This was the moment of his conversion, for the next night Jesus appeared to him in a dream wearing that very piece of cloak and, addressing the angels, praised Martin's charity. The saint then asked for baptism and left his military career. Very soon artists began depicting the meeting with the poor man and the charitable donation of the cloak. Martin is most often depicted as a soldier on horseback although there are examples in which he is shown on foot. In some cases items of a bishop's insignia are present even though this episode took place at the beginning of his conversion and thus long before he was named bishop.

Giovanni Francesco Nagli,
Charity of Saint Martin,
1629–75, collegiate church,
Verucchio (Rimini).

Diego of Alcalá

Feast day: November 12

Appearance: young man wearing a Franciscan habit

Attribute: flowers held in the folds of the habit

The saint was guardian in the convent on the Canary Island of Fuerteventura, cook, and layfather in other convents in Andalusia, and he served in the convent of Aracoeli in Rome. Thus, a life of prayer and service to his brothers as well as to the poor and pilgrims are the factors that have defined the figure of Diego of Alcalá (so-called after the last convent he lived in) in art. He is depicted as a youth—because he was very young when he chose the religious life—wearing the brown habit of the Franciscan family, whose rule he embraced, and is made recognizable by the flowers he displays amid the folds of his habit. This image refers to an episode in Diego's life, according to which another friar in the convent, suspecting that Diego, out of his exaggerated generosity, was taking food from the kitchen to give to the poor, stopped him and searched among the folds of his habit only to find flowers.

Biographical notes

Born in Andalusia around 1400, while still young Diego chose the religious life and joined the Franciscans. He was a layfather; dedicated to the care of the sick and pilgrims, he was assigned the role of cook. He died at Alcalá in 1463.

Patronage

Invoked against infirmities

Francisco de Zurbarán,
Saint Diego of Alcalá,
1651–53, Fundación Lázaro
Galdiano, Madrid.

Albert the Great

Feast day: November 15

Appearance: wears the white habit and black mantle of the Dominicans

Attributes: crosier, miter, book, pen, rarely scientific instruments or leaves as objects of natural studies

The fundamental element in the saintly life of Albert, member of the noble Bollstadt family of Swabia, was his having entered the order of preaching friars at a young age and against his parents' wishes. For this reason his principal element of recognition is the white habit with black mantle of the Dominican friars. Because of his studies and his training he taught in several universities; his recurrent image is therefore that of a scholar at his desk or simply holding a book or pen. In rare cases he wears the headdress of a doctor, and he appears more often wearing a bishop's miter, having been elected bishop of Regensburg in 1260. However, since he resigned that position after only two years to dedicate himself to teaching and writing, the miter is often depicted off to one side, sometimes together with a crosier.

Biographical notes

Born into a noble family in Swabia, Germany, in 1206, Albert entered the Dominican order at Padua in 1223. He taught at Hildesheim, Regensburg, and Cologne before teaching theology at Paris. Provincial prior between 1254 and 1257, in 1260 he was elected bishop of Regensburg. He died in 1280.

Patronage

Protector of scientists, students of natural sciences, and naturalists

Tommaso da Modena, *Saint Albertus Magnus, Doctor of the Church*, from the series *Forty Illustrious Members of the Dominican Order*, 1352, ex-convent of San Niccolò, chapterhouse, Treviso.

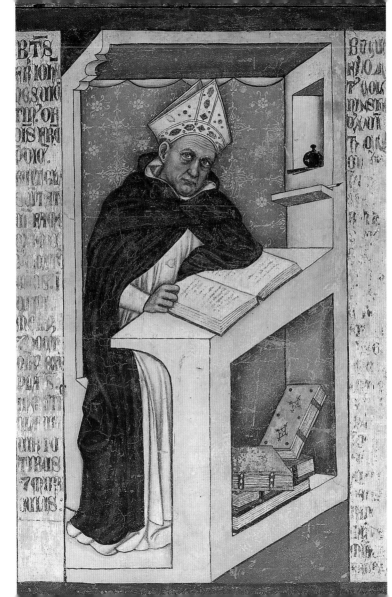

Elizabeth of Hungary

Feast day: November 17

Appearance: wears the clothes of a princess, sometimes over a Franciscan habit

Attributes: crown, coins for charity, pitcher, basket of bread, fruit, fish; sometimes she bears a basket or apron full of roses

Can be confused with: Saint Elizabeth of Portugal

Saint Elizabeth of Hungary's images reflect the two different phases of her life. The regal appearance refers to her lineage—she was a princess, daughter of the king of Hungary—the education she received in Thuringia in the castle of Wartburg, her marriage to Louis IV, and her life as a wealthy landowner. The depictions of her as a charitable soul giving service to the poor, as seen in her attributes of coins, bread, fish, and the pitcher for water, were used to present Elizabeth as the wife of Louis IV and the happy mother of three children to some degree, but her charity became the focus of images of the saint after her husband's death and her withdrawal from court. That was followed by her decision to enter the Franciscan tertiaries, which explains the depictions of the saint in which beneath regal gowns she is seen to be wearing the habit and cord belt.

Biographical notes

Born in 1207, she was the daughter of the king of Hungary. She married Louis IV in 1221 and was the mother of three children. She was always dedicated to the care of the poor. After her husband's death she entered the Franciscan tertiaries. She died in 1231.

Patronage

Protector of bakers and Franciscan tertiaries

Girolamo di Benvenuto (attr.), *Saint Elizabeth of Hungary*, 15th century, Basilica dell'Osservanza, Siena.

Cecilia

The principal attribute of Saint Cecilia was originally a small portable organ, but it later became almost any musical instrument, all of it the result of an error in transcription that has also had an influence on her legend. The reference to music is derived from the erroneous repetition of a section in the *Passio Sanctae Ceciliae*, the words "*canticus organis*" written in reference to the music of her wedding celebration. As a young Christian, she was engaged to a pagan named Valerian. Maintaining her vow of virginity she converted her husband who agreed to be baptized and also converted his brother Tiburtius. All three died martyrs, first Valerian and Tiburtius and then Cecilia, who was beheaded after refusing to sacrifice to the idols.

Biographical notes
A Christian martyr of the third century, she converted her husband, Valerian, and his brother to Christianity, and they were both martyred before she was.

Patronage
Protector of musicians, makers of stringed instruments, poets, and singers

Guido Reni, *Saint Cecilia*, 1606, Norton Simon Museum, Pasadena.

Cecilia

Before the fourteenth century and the spread of the erroneous reading of the *Passio Sanctae Ceciliae* (which led to the mistaken association of Cecilia with music and made her the patron saint of musicians, singers, and poets), the image of Saint Cecilia was the more generic one common to other martyred virgins: Her attributes were the palm branch and a crown of flowers (worn on her head or held near her), an award for martyrdom along with the palm.

Bernardo Daddi, *Saint Cecilia*, early 14th century, Museo Diocesano, Alberto Crespi Collection, Milan.

Clement I

Feast day: November 23 in West, November 24 in East

Identifying situation: being thrown from a ship with an anchor around his neck

Appearance: wears papal robes

Attribute: anchor

The church recalls the martyr saint Clement I on the day on which his body was buried in Rome. Few details of his life are known with any certainty: he was the third successor to Saint Peter, thus the fourth bishop of Rome, or pope; he is also known for having written an epistle to the Corinthians to reinforce peace and concord among the faithful. Before the fourth century, when the hardly believable and fantastic Acts related to Saint Clement came into circulation, figurative Christian art did not yet really exist, for which reason the earliest depictions of Clement were made on the basis of sources that are today considered apocryphal. The situation with the iconography of Saint Clement can be taken as a typical example of how iconography is built from both fact and fiction, since it is composed of clothing that corresponds perfectly to his history, meaning the attributes of a pope, together with a symbol—an anchor—which, fruit of an erroneous interpretation, has in turn had its influence on his legend.

Biographical notes
He lived in the first century and was the fourth bishop of Rome, from 88 to 97.

Patronage
Invoked against diseases in children; protector of hatters, boatmen, watermen, gondoliers, stonecutters, sailors, and sculptors

Andrea da Bologna, *Pope Saint Clement I*, 1359–67, Lower Basilica, Basilica of Saint Francis, Assisi.

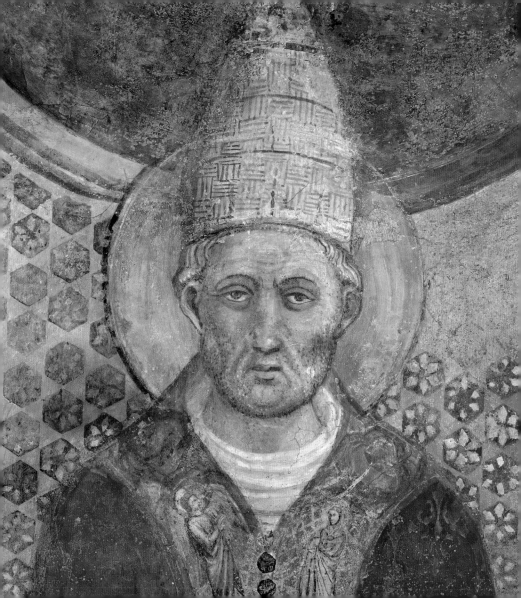

Clement I

The anchor was a symbol much used by early Christians in the cenotaphs on the sepulchers in the catacombs. With a shape that recalls the sign of the cross, it is at the same time an emblem of the stability of faith. As such the symbol was also used on the tomb of Saint Clement, but with the passing of time it lost its original meaning to the point that the anchor was taken instead to be an indication of the instrument of the saint's martyrdom. From this a legend was born and later included by Jacobus de Voragine in *The Golden Legend*. It told how Saint Clement had been exiled to Crimea and forced to work in mines. There he had been martyred by being thrown from a ship with an anchor around his neck. In that way the ancient iconographic attribute of a Christian in general came to be used as the specific attribute of Pope Clement.

Saint Clement, miniature in the
Breviary of Isabel of Castile, c. 1439,
British Library, Ms. Additional 1885l,
fol. 494 r., London.

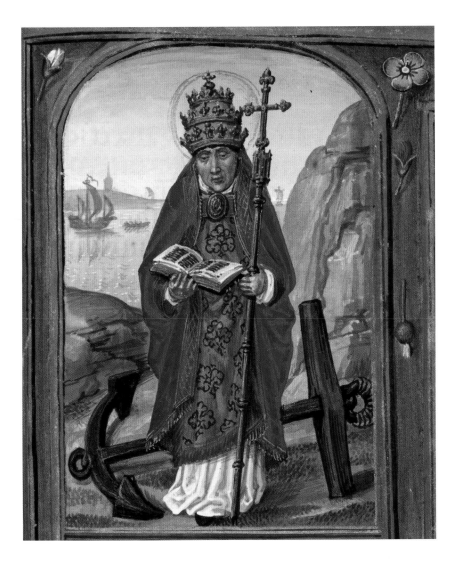

Catherine of Alexandria

Feast day: November 25

Identifying situation: martyr with a spiked wheel

Appearance: wears regal robes, in particular a crown on her head

Attributes: palm leaf, sword, wheel, ring of mystical matrimony

Biographical notes
A martyr of the fourth century, probably of noble lineage, she was tortured with a spiked wheel and then beheaded under Emperor Maxentius.

Patronage
Invoked by nursing women, shipwreck victims, and against migraines; protector of orators, philosophers, notaries, tailors, stylists, spinners, carters, nursing mothers, and wet nurses

The spiked wheel, often broken, is the unmistakable element that identifies the martyr saint Catherine of Alexandria. The only certain information about her person celebrates her wisdom and her veneration in the monastery of Mount Sinai. Her special martyrdom, as collected and handed down in *The Golden Legend,* is derived from a reworking of the symbols that were originally attributed to her. A wise woman who had turned to Christ, she was able to confound and reduce to silence the most important philosophers summoned by the emperor Maxentius to confute her faith. This wisdom was originally represented as a circle, the ancient symbol of inspired wisdom. This was later confused with a wheel, and in the Middle Ages the legend of her torture by means of a wheel was invented, the torture being interrupted by the intervention of an angel (which is how the wheel got broken). In some images the wheel was a very small symbol, so small that it was later read as a ring, thus becoming the perfect emblem for depiction of the mystical marriage, an iconographic theme already present in the Middle Ages but very widespread in the fourteenth and the fifteenth centuries.

Bernardo Zenale, *Saint Catherine of Alexandria*, 1508, Museo Bagatti Valsecchi, Milan.

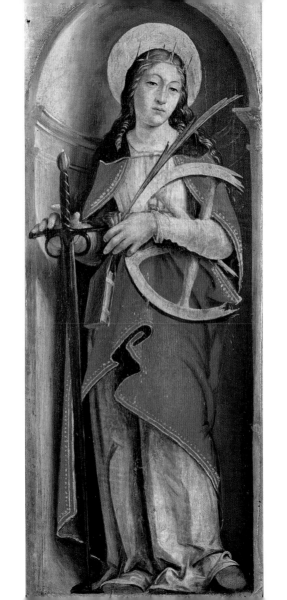

Andrew

Feast day: November 30

Appearance: mature man, sometimes in classical dress

Attributes: X-shaped cross, fishing nets or fish

According to apocryphal tradition, a cross with equal-length arms forming an X was the instrument of the martyrdom of the apostle Andrew, an event that took place at Patras in Achaea following his preaching—after the ascension of Jesus—in Pontus Euxinus (the Black Sea), Cappadocia, Bithynia, Galicia, Scythia, and perhaps also Georgia. The X-shaped cross soon became the iconographic attribute and unquestionable factor for recognizing the apostle Andrew. In the earliest depictions he was shown with an ordinary small processional cross, but it later assumed the shape of the special cross that, precisely because of the saint, has come to be known as the cross of Saint Andrew. Another element that can be used for recognizing Saint Andrew that sometimes appears in depictions of him is fishing nets or fish, an element that is derived from the period of his life before he was called by Jesus.

Biographical notes
He lived in the first century in Palestine and was one of the twelve apostles chosen by Christ.

Patronage
Protector of fishermen and fishmongers

Peter Paul Rubens,
Martyrdom of Saint Andrew,
1638–39, Fundación Carlos
de Amberes, Madrid.

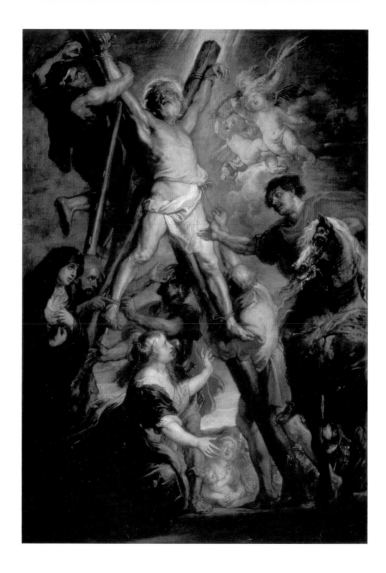

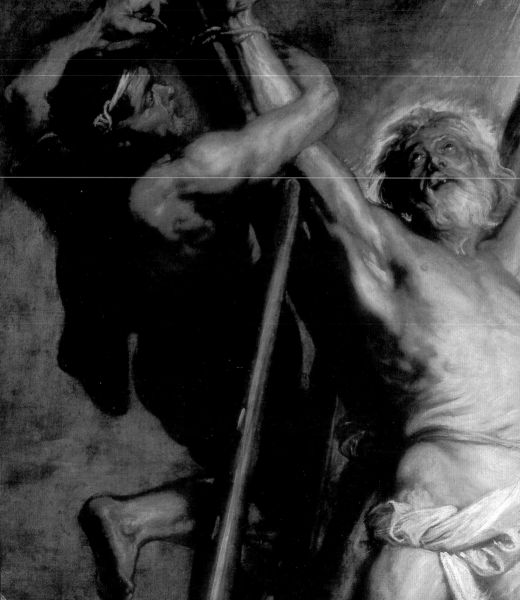

Eligius

Feast day: December 1

Appearance: most often a goldsmith or blacksmith, sometimes a bishop

Attributes: horseshoe or horse

A good part of the iconography of Saint Eligius, as well as the choice of his attributes, dates to the activity he conducted before becoming a priest and being named bishop. Born around 588 in Chaptelat, near Limoges, he initially worked as a blacksmith and then as a skilled goldworker, much appreciated for his creations in the most prestigious circles, so much so that he was made director of the mint and adviser to the royal treasury. Among his many talents was the economical use of materials and avoiding waste. King Chlotar II is said to have praised him for having been able to make two thrones using the quantity of gold allocated for the creation of only one. He is thus most often encountered in the guise of a blacksmith or goldsmith busy at work with the tools of the trade, although his image as a bishop is also moderately widespread.

Biographical notes
Born near the end of the sixth century (around 588) near Limoges, he was a blacksmith and goldworker ordained priest in 641 and named bishop of Noyon that same year. He died in 660.

Patronage
Invoked against ulcers, earaches, and enteritis; protector of goldsmiths, blacksmiths, and garage workers

Taddeo Gaddi, *Saint Eligius Goldworker*, 1365, Prado, Madrid.

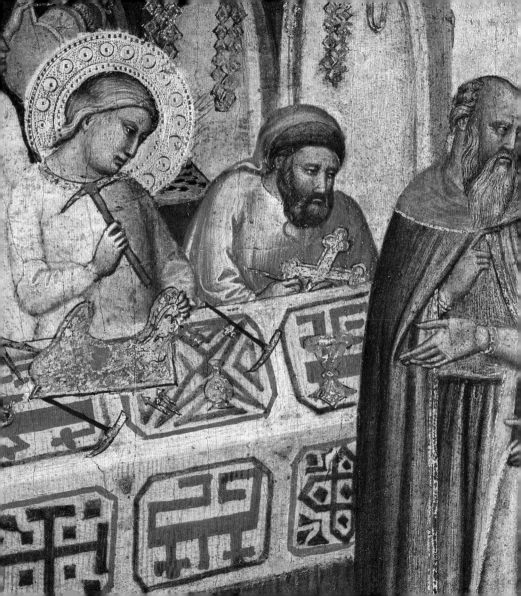

Eligius

The image of Saint Eligius as a blacksmith, his first occupation (after which he became a goldsmith, then later bishop of Noyon), turns up primarily in older depictions of the saint and is based on a specific episode that is also the source of the attribute of the horse. It is said that Eligius boasted of being able to shoe horses with a rapidity never before seen; a young man then presented himself boasting of greater skills, who shoed a horse by removing its leg, which he then reattached to the animal making the sign of the cross. Seeing this Eligius was humbled and asked pardon of the Lord. According to other versions, the young man was a stable hand who worked in the stable of Eligius and treated restless horses in this way. In this version of the story, the young stable hand is said to be Christ, who then taught Eligius to remove the equine leg of a demon. The legend of the devil presenting himself to Saint Eligius in the form of a woman and being foiled when the saint unmasked him by grabbing hold of his nose with pincers has not had much influence on the iconography of the saint.

Gaetano Gandolfi, *Miracle of Saint Eligius*, late 18th century, Louvre, Paris.

Francis Xavier

Feast day: December 3

Appearance: wears a priest's clothes, sometimes with a cape

Attributes: crucifix, baptismal bowl, Native Americans, a flaming heart, lily, hat, cape, crab

Can be confused with: Saint Ignatius of Loyola

The love for Jesus Christ and the desire to evangelize in the most distant lands until stopped by death are the characteristic traits that have determined the biography and iconography of Saint Francis Xavier. His first attribute is a crucifix held tight to the chest or held up as a sign of preaching. Among the objects that accompany him are the bowl for aspersion in the rite of baptism (in relation to the many baptisms performed by the saint among the populations of Native Americans), a pilgrim's staff, and sometimes the branch of flowering lily. In rare cases there is a large crab in memory of a miracle in which such a crab returned to him a crucifix that had fallen into the sea. Saint Francis Xavier's ardent love is symbolized by the flaming heart or simply by flames that seem to exit his chest.

Biographical notes
A Spanish priest from a noble family, Francis Jassu y Xavier was born in 1506 in Navarre. With Ignatius of Loyola he founded the order of the Jesuits and passionately dedicated himself to the apostolate in India and Japan. He died on Saint John Island en route to China, in 1552.

Patronage
Invoked against the plague, storms, and hurricanes; protector of missionaries, sailors, and tourists

Francisco de Zurbarán, *Saint Francis Xavier*, Fundación Lázaro Galdiano, Madrid.

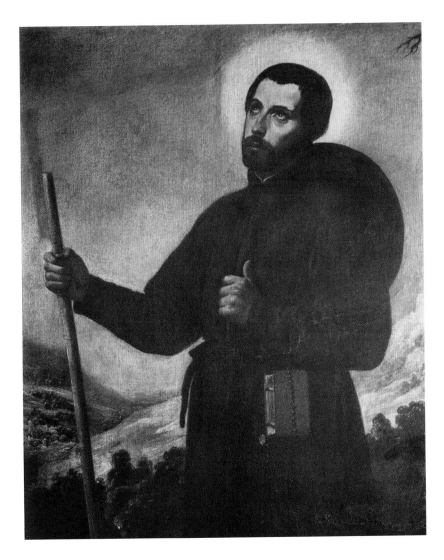

Barbara

Feast day: December 4

Identifying situation: a tower in which she is enclosed

Appearance: a young woman

Attributes: tower, palm branch, peacock feathers

The principal attribute of Barbara is the tower. According to apocryphal sources, Barbara was the daughter of the king of Nicomedia, Dioscorus, who enclosed her in a tower so that no one could see her. That did not prevent suitors from reaching the young princess, but she had become a Christian and decided to live as a hermit in the tower her father had built for her, to which she added a third window in honor of the Trinity. Blinded by his rage, the king denounced her to the prefect, who tried to kill her. After numerous tortures—including flagellation, although the whips were miraculously transformed into peacock feathers (for which reason peacock feathers sometimes appear as an attribute of this saint)—she was beheaded, after which Dioscorus was immediately incinerated by a bolt of lightning.

Biographical notes
Barbara was a martyr of the early fourth century.

Patronage
Invoked against lightning; protector of architects, gunners, weapons makers, miners, masons, firemen, bell-founders, and those in constant risk of death

Bartolomeo Vivarini, *Saint Barbara*, 1490, Gallerie dell'Accademia, Venice.

Nicholas

Feast day: December 6

Appearance: wears bishop's vestments

Attributes: three golden balls, sometimes three boys in a tub, anchor, ship

Biographical notes
Nicholas was born in Lycia, Turkey, in the third century. Before being ordained priest, he was acclaimed bishop of Myra, leading the dioceses with charity, dedication, and full respect for orthodoxy. He died at Myra around 343. His cult spread through the Byzantine Empire in the sixth century and took hold in Europe after the translation of his relics to Bari in 1087.

Patronage
Protector of children, students, the poor, sailors, fishermen, pilgrims, and perfumers

The most common and specific attribute of Saint Nicholas is the image that synthesizes a particular episode of his youth, from before he was proclaimed bishop and ordained priest, an episode that became very popular for describing his generosity and goodwill. The three gold balls the bishop holds in his hand or that rest atop a closed book are a modification of the three bags of gold with which the young Nicholas saved three girls from prostitution by providing them with dowries that they found in their own home (he tossed the purses through a window at night). The three boys in the tub are a reference to a miracle of resurrection, when the bishop Nicholas brought back to life three boys who had been kidnapped by a butcher, killed, and hidden in a tub. From this and other acts, Nicholas became the patron saint of children, and from there he grew into the figure of Santa Claus. The anchor and the ship are symbols that have been attributed to him for having been elected protector of sailors and for having saved postmortem a ship from sinking.

Saint Nicholas of Bari (detail), from the retable of the Holy Cross, early 15th century, Sospel cathedral.

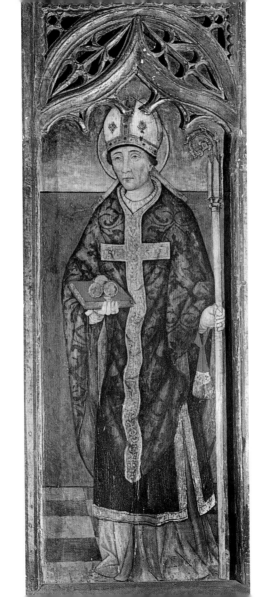

Nicholas

The original images of Saint Nicholas were conceived in a Byzantine setting well before the saint's cult spread to the West following the translation of his relics to Bari, which generated the legends that are behind the saint's best-known iconography. The original depictions are thus very simple and correspond to that of a bishop of the Greek Church with the white pallium (band of wool worn over his shoulders) decorated with painted crosses, with his head bare (an element maintained in his image in the West on those frequent occasions when he did not wear a miter), and with his right hand raised in blessing, while his left holds a cross or the book of the Gospels.

Icon of Saint Nicholas with Stories of the Saints, 13th century, Pinacoteca Provinciale Corrado Giaquinto, Bari.

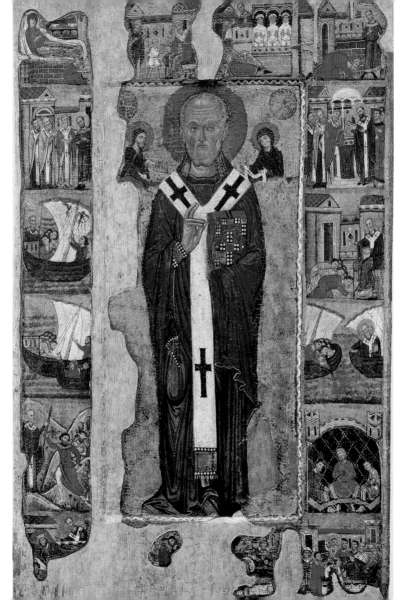

Ambrose

Feast day: December 7

Appearance: mature man with beard, wears bishop's vestments, sometimes shown on horseback

Attributes: scourge, crosier, miter, book, bees

The scourge, a kind of whip with a handle and several lashes, is an unmistakable symbol of Ambrose. Saint Ambrose is usually depicted in bishop's vestments with the crosier and miter, and most often he appears as a mature man with a thick beard. The iconographic attribute of the whip appeared only in the Middle Ages (twelfth century), as a symbol of the struggle against heresies, and became consolidated later with the miraculous apparition of the saint at the battle of Parabiago (1339), where, arriving on a white horse and brandishing a whip, he routed the enemies of the Visconti. As Doctor of the Church, he can also be shown studying.

Biographical notes
Born at Trier, Germany, into a Christian family, he studied in Rome and became a brilliant lawyer. Although not yet baptized, he was named bishop of Milan in 374 by popular acclamation; he was baptized and consecrated in a week. He battled the Arian heresy and completed important liturgical and pastoral reforms. His cult spread immediately after his death in 397.

Patronage
Protector of beekeepers, bees, and those who work with wax

Vincenzo Foppa, tondo with *Doctor of the Church (Saint Ambrose)*, 1468, basilica of Saint Eustorgio, Milan.

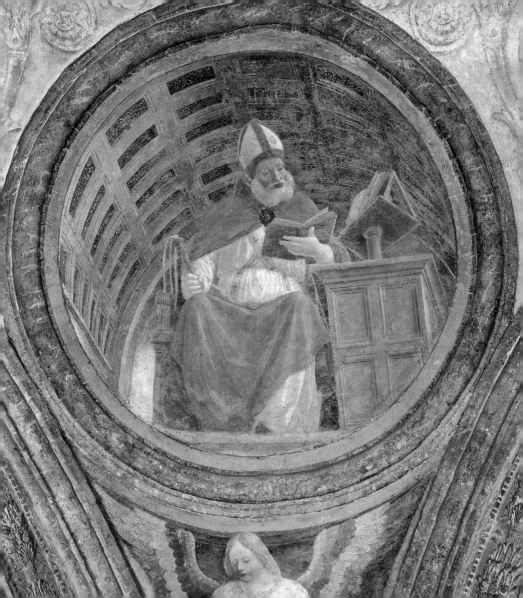

Ambrose

A particularly interesting element in the iconography of Bishop Ambrose is the image of a child sleeping in a cradle or bed with bees that fly around him and rest on him, apparently going in and out of his mouth. This motif (which also appears in the iconography of Bernard of Clairvaux, although in a different context) is based on the biography of the saint written by Paulinus of Milan in 422. The newborn Ambrose was surrounded in his crib by a swarm of bees that covered his face, but his father would not permit anyone to intervene, and when the bees went away he said, "If this child lives, he will be something great." The biographer also revealed the significance of the bees, explaining, "Well-ordered words are as a honeycomb. For that swarm of bees was implanting the honeycomb of his later works."

Three bees leave the mouth of Ambrose, miniature from the *Book of the Saints*, 13th century, Musée Condé, Chantilly.

Lucy

Feast day: December 13

Appearance: young woman, sometimes tied to multiple pairs of oxen

Attributes: palm branch, eyes on a plate, sword or dagger, lantern

Can be confused with: Saint Odile of Alsace, whose attribute is a pair of eyes on a book

The name Lucy, which is related to light, has established many of the attributes of this martyr saint from Syracuse. The best-known and most widespread image is that of her eyes, most often presented on a plate or tray, sometimes strung together on a stick. Her name inspired the legend according to which the various tortures the saint suffered before being stabbed in the throat and then beheaded included having her eyes dug out (she herself put them back in place). Although this episode is not included in *The Golden Legend*—which instead tells of how steadfast Lucy was in her testimony to the prefect, so firm in fact that she could not be moved even by many pairs of oxen— the attribute of the eyes, along with the palm branch of the martyr, has always been the unmistakable element in the iconography of this saint in art.

Biographical notes
Born into a noble family of Syracuse, Sicily, Lucy gave her belongings to the poor and renounced matrimony. She was martyred around 304 during the persecutions under Diocletian.

Patronage
Invoked against ophthalmia and hemorrhages; protector of the blind, electricians, and eye doctors

School of Zurbarán, *Saint Lucy*, 17th century, Museu de Montserrat, Montserrat.

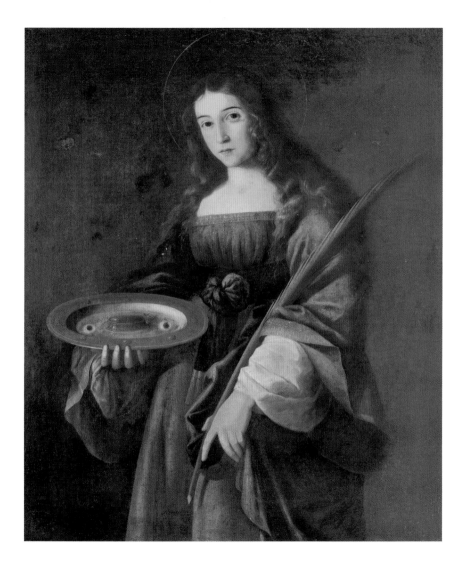

Lucy

In the oldest depictions of Saint Lucy, eyes are not used as her attribute (her disembodied eyes make their appearance in art only beginning in the fourteenth century). Instead, she is associated with a lamp, which was depicted as early as the thirteenth century. The choice of this object with its connection to light (and bringing with it reference to faith and vigilance, with a possible reference to the biblical text that relates the parable of the wise virgins) was derived from the assonance of the saint's name with the Latin word for lamp, *lucerna*. Thus a lamp appears along with a book, symbolic of the disciple who holds dear the Word of God, and the instrument of her martyrdom, a sword or dagger, sometimes stuck in her chest or neck.

Filippino Lippi (attr.), *Saint Lucy*, late 15th century (?), Prato Cathedral.

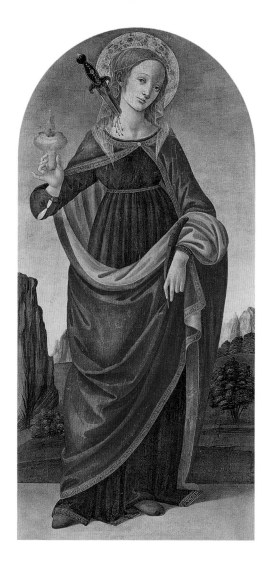

John of the Cross

Feast day: December 14

Appearance: wears the brown habit with scapular and white mantle of the Carmelites

Attributes: cross, sometimes a book with the words *Pati et contemni*

The primary attribute for recognizing Juan de Yepes y Álvarez is the crucifix in front of which the saint meditates, always in combination with the other characteristic element, the brown habit of the Discalced Carmelites, the order he reformed in 1568. The name by which he is known, John of the Cross, is derived from the unique object present in his cell, a poor cross of reeds, together with his habit of spending long hours of the night lying in the open in meditation with his arms spread out in the form of a cross. Not a trace of that habit shows up in his iconography, but there is his rapt absorption in front of a crucifix or of Christ himself, who appeared to him with the cross and the instruments of his Passion, such that the cross can be taken as his distinctive sign along with the brown habit and scapular (long band of cloth with an opening for the head) and white mantle. There was also the occasion when he heard the words, "What do you want as a reward for your labors?" The question came from God, and John answered, *"Domine pati et contemni pro te"* ("Lord, to suffer and be despised for you").

Biographical notes

Born in Spain in 1542, Juan de Yepes y Álvarez entered the Carmelite order in 1563. He reformed the order, founding the order of the Discalced Carmelite friars. He was a great mystic. He died in 1591.

Patronage

Protector of mystics, theologians, and poets

Anonymous painter, *Saint John of the Cross*, 16th century, Carmelite convent, Beaune.

Stephen

Feast day: December 26

Appearance: young man with tonsure, wears the habit of a deacon with dalmatic and stole worn crosswise

Attributes: stones, book, palm branch

Stones, the instrument of his martyrdom, are the attributes that make recognition of Saint Stephen, the first martyr, possible. In the most instructional depictions, one or more stones can be directly attached to his head; in other cases he has the stones in his hands or holds instead a book (symbol of his preaching the Word of God) with the stones arranged atop it. Appearing together with the stones is the palm branch that is the symbol of his martyrdom. The image of the saint is that of a young man with the tonsure (shaven crown) in the dress of a deacon, including a dalmatic or a tunicle or a stole worn crosswise, according to the usage of the church at the time that the depiction was created.

Biographical notes

Stephen lived in the first century and was one of the seven deacons of Jerusalem named by the apostles. The first martyr, he was stoned to death after being taken to the Sanhedrin and accused of blasphemy against Moses and against God and after demonstrating how the Jews refused to recognize Christ the Messiah.

Patronage

Invoked against migraines and for a good death; protector of deacons, bricklayers, slingers, masons, stone-dressers, stone-cutters, and pavers

Giotto (attrib.), *Saint Stephen*, 1310–36, Horne Foundation, Florence.

Stephen

The Acts of the Apostles provides a detailed account of the events that led to Stephen's death. It reports how Stephen's preaching angered the Jews, who brought him before the Sanhedrin, where he was blamed by false witnesses and accused of blasphemy. The text includes the sermon with which Stephen replied to the charges, the reasons for his faith in Christ. At the end of the sermon Stephen said, "Behold, I see the heavens opened, and the Son of man standing on the right hand of God." He was immediately taken out of the city and stoned to death. Depictions of the martyrdom present Stephen's vision in the moment of his death, when he fell to his knees and asked pardon for his assassins ("Lord, lay not this sin to their charge"). The figure of the young Saul (who on his conversion changed his name to become Saint Paul) is often included in such images, with the mantles of the witnesses heaped at his feet.

Giorgio Vasari, *The Stoning of Saint Stephen*, 1573, church of Santo Stefano dei Cavalieri, Pisa.

John the Evangelist

Feast day: December 27

Appearance: young, beardless

Attributes: eagle, book; he may hold a cup with a viper in it

Saint John the Evangelist can be found in numerous images that present moments from the life of Jesus and can be distinguished from the other apostles because he is the youngest, for which reason he is shown beardless. In some contexts, such as the crucifixion or the Last Supper, aside from his youth his location leaves no room for doubt: In crucifixion scenes he is near the cross, is supporting the Virgin, or sits alone to the left of Jesus; in the Last Supper he is always near Christ, often resting his head on his chest. As evangelist he is depicted in the act of writing; his specific symbol, after the book, is the eagle, attributed to him because his Gospel, being the most spiritual, lifts the spirit on high.

Biographical notes

The son of Zebedee, John was among the first disciples of Jesus and was perhaps the youngest. He was the only one who did not abandon Jesus at the moment of crucifixion. Before dying Jesus entrusted his mother to him. Toward the end of his life he wrote his Gospel; he also wrote the book of Revelation.

Patronage

Invoked against false friends; protector of booksellers, writers, theologians, artists, templars, stationers, and typographers

Pedro Berruguete, *John the Evangelist* (detail), from the retable of Saint Thomas, late 15th century, convent of Saint Thomas, Avila.

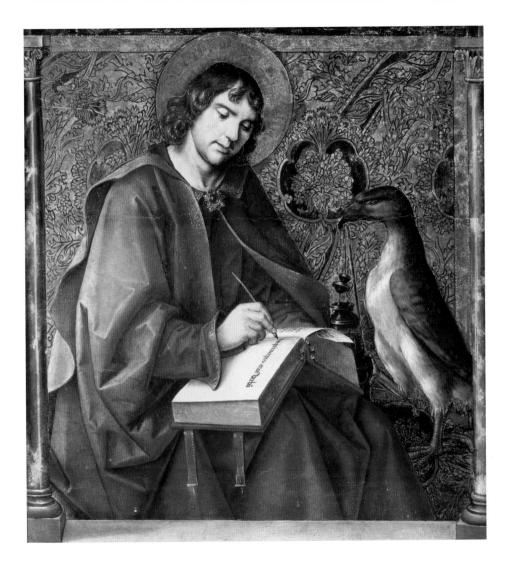

John
the Evangelist

There are depictions of Saint John in which the evangelist's usual attributes are set aside to emphasize the symbol of a cup, from which rises one or more small vipers or sometimes even a small winged dragon. This attribute is related to a miraculous episode drawn from apocryphal sources: Saint John was challenged by Aristodemus, high priest and leader of the idol-worshippers, to drink a cup of poison or renounce his preaching about Jesus Christ. Saint John took the cup, blessed it with a long prayer, and made the sign of the cross, after which several serpents were seen to leave the cup, symbols of the evil that had poisoned the contents. John then drained the cup and was unharmed, convincing the priest who had challenged him and who in the end converted.

Cristoforo Scacco, *Saint John the Evangelist and a Benedictine Saint*, 15th century, Museo Nazionale di Capodimonte, Naples.

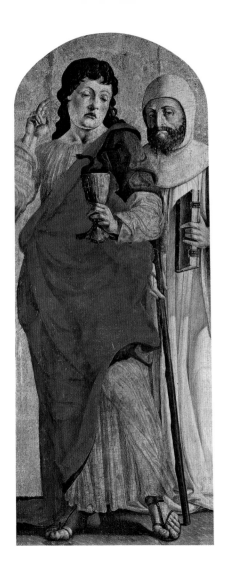

Thomas Becket

Feast day: December 29

Identifying situation: priest attacked by four knights near an altar

Appearance: wears bishop's vestments and has a wound to the head

Attributes: miter, crosier, book, sword

Can be confused with: Saint Peter of Verona, who experienced a similar martyrdom but wears a Dominican habit

Biographical notes

Born in London around 1117, Thomas studied theology and church law and was collaborator of the bishop of Canterbury. As a strenuous defender of the rights of the church and a thoughtful preacher, he came into conflict with King Henry II, who had wanted him as his personal adviser but became so angry with him that in 1170 he had him killed by four knights.

Patronage

Protector of the English College in Rome, coopers, and the makers of brooms

What renders Saint Thomas Becket, archbishop of Canterbury, recognizable is a combination of various iconographic elements. First are the attributes related to his position as bishop, from his vestments to the crosier, book, and miter; then there is the emblem of his martyrdom, a sword blow to the head (sometimes expressed by way of a sword embedded in the saint's head); finally there is the setting of the tragic event, the cathedral of Canterbury. The site of the martyrdom of Saint Thomas Becket is usually indicated as the altar, with the saint standing near it.

Murder of Thomas Becket in the Cathedral of Canterbury, from the Codex Psalmorum Membranaceus, c. 1200, British Library, Ms. Harley 5102, fol. 32, London.

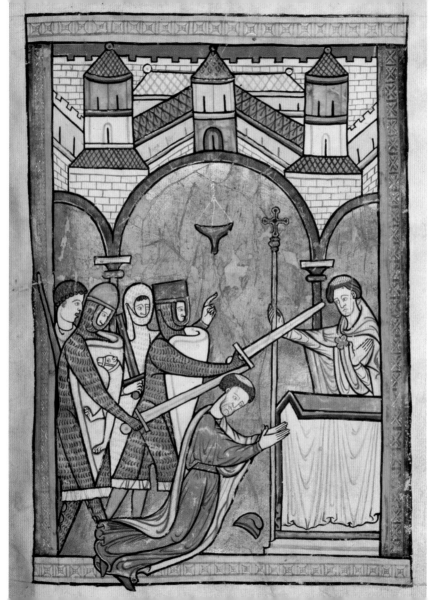

Sylvester I

Feast day: December 31

Appearance: wears papal robes

Attributes: bull, dragon, baptismal font

The image of Saint Sylvester I as pope is somewhat difficult to distinguish from the images of other sainted popes, all of them uniformly distinguished by papal robes, meaning the cope over their shoulders and the tiara on their head. What makes Sylvester recognizable are not objects but animals, a bull and a dragon. The bull, usually shown at the pope's feet, is based on one of the legendary stories that have become part of his hagiography, according to which he brought back to life a bull that had been killed by a magician. The dragon that is sometimes shown near Sylvester refers to a dragon guarded by the Vestals that he subdued, holding the crucifix in his hand and enclosing it definitively in its underground lair.

Biographical notes

Sylvester I was the first pope after Constantine's Edict of Milan (313) granting Christians freedom of worship. His pontificate lasted twenty years and included the famous Council of Nicea against the Arian heresy (325). Sylvester died in 335.

Patronage

Protector of domestic animals, bovines, masons, and stonecutters

Maso di Banco, *Saint Sylvester's Miracle (Turning a dragon out of the Roman Forum and reviving its victims)*, 1337–41, basilica of Santa Croce, Florence.

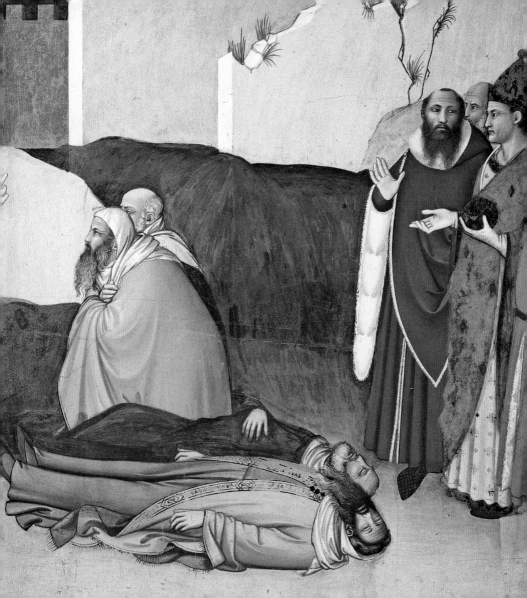

Index of Saints

Image Credits

Art director
Dario Tagliabue

Editorial director
Virginia Ponciroli

Editor
Carla Volpi

Graphic coordination
Lucia Vigo

Layouts
Elena Brandolini

Cover
Darilyn Lowe Carnes

Director art research
Elisa Dal Canto

Art research
Chiara Sordi

Technical coordination
Lara Panigas

Quality control
Giancarlo Berti

English translation
Jay Hyams

English-language typesetting
Michael Shaw